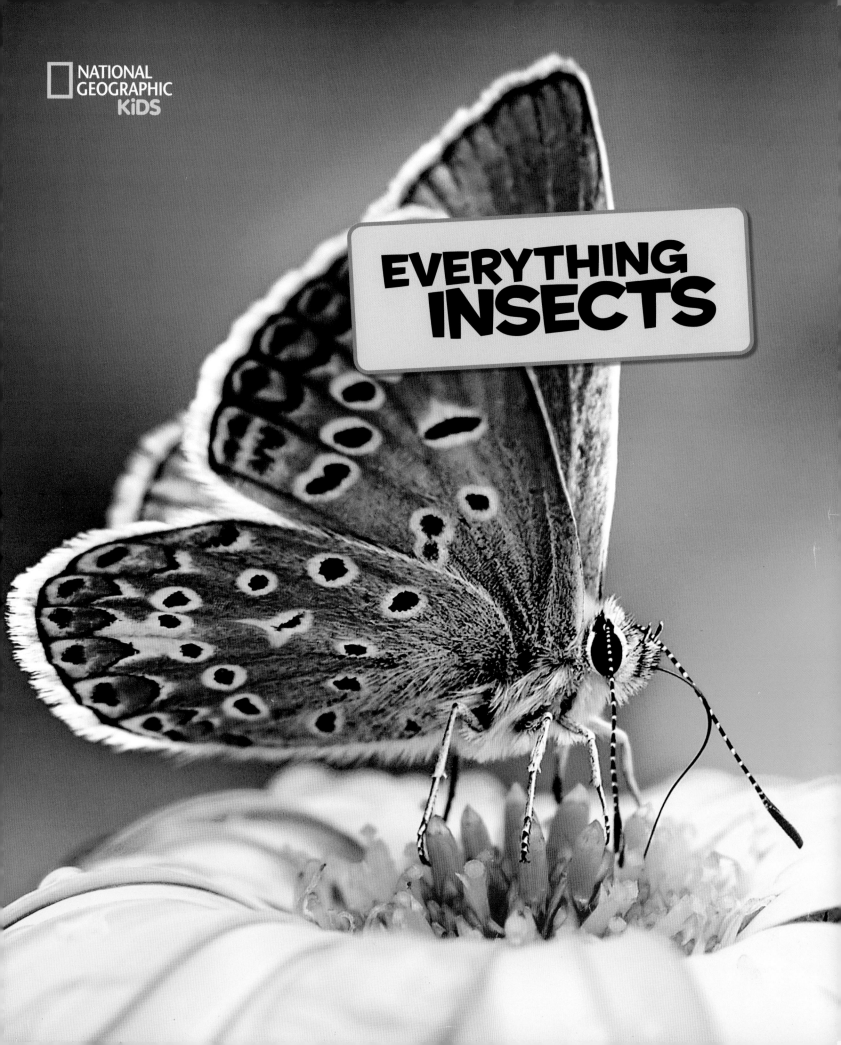

# EVERYTHING INSECTS

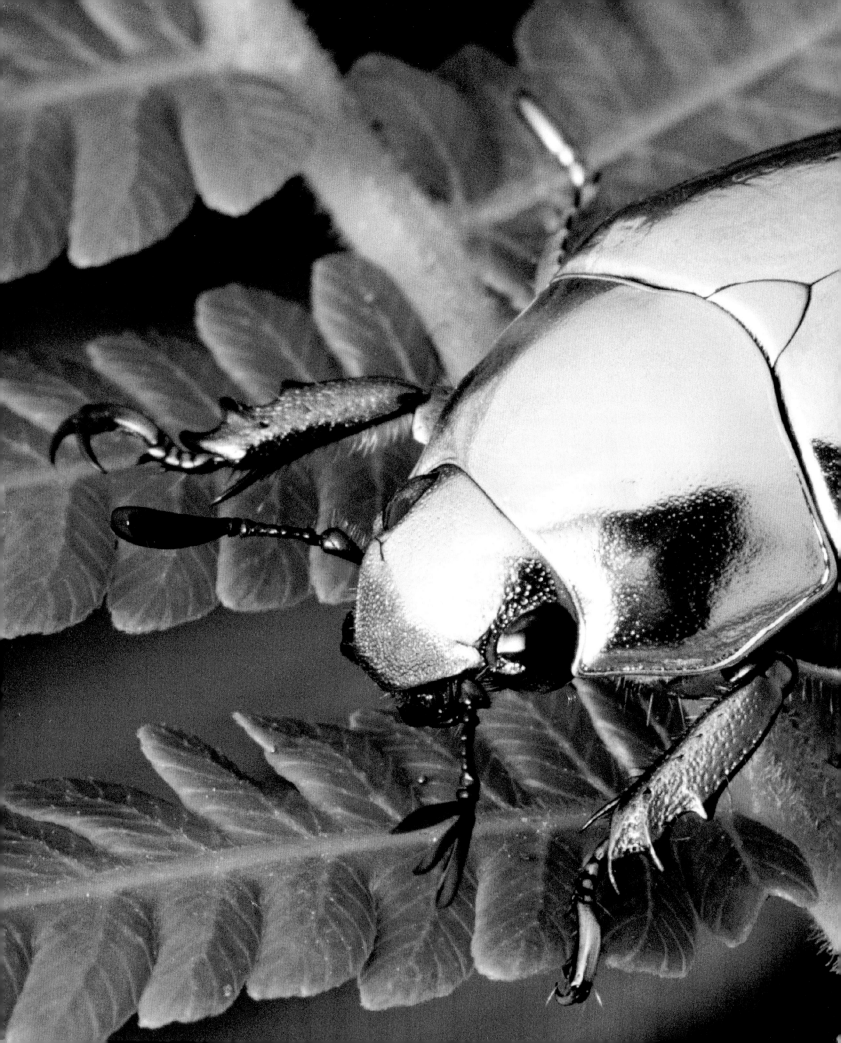

# EVERYTHING
# INSECTS

**CARRIE GLEASON**

With National Geographic Explorer DINO J. MARTINS

NATIONAL GEOGRAPHIC
WASHINGTON, D.C.

# CONTENTS

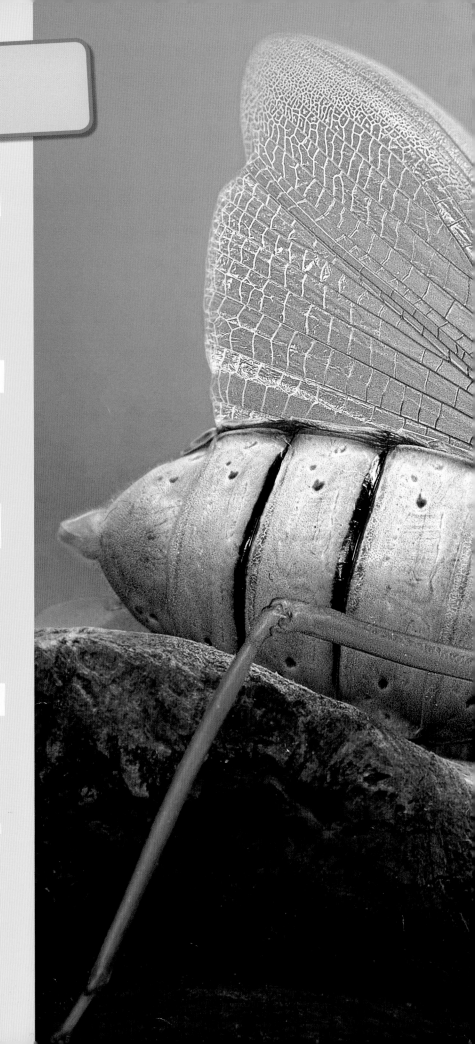

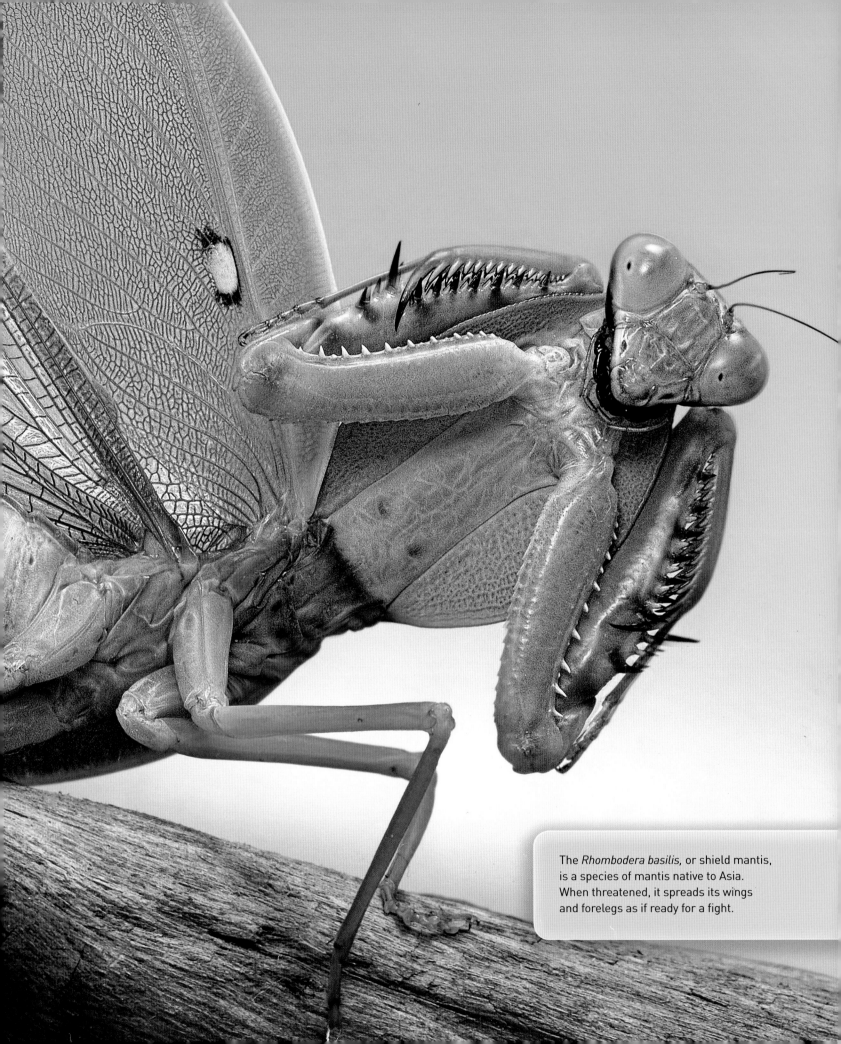

The *Rhombodera basilis*, or shield mantis, is a species of mantis native to Asia. When threatened, it spreads its wings and forelegs as if ready for a fight.

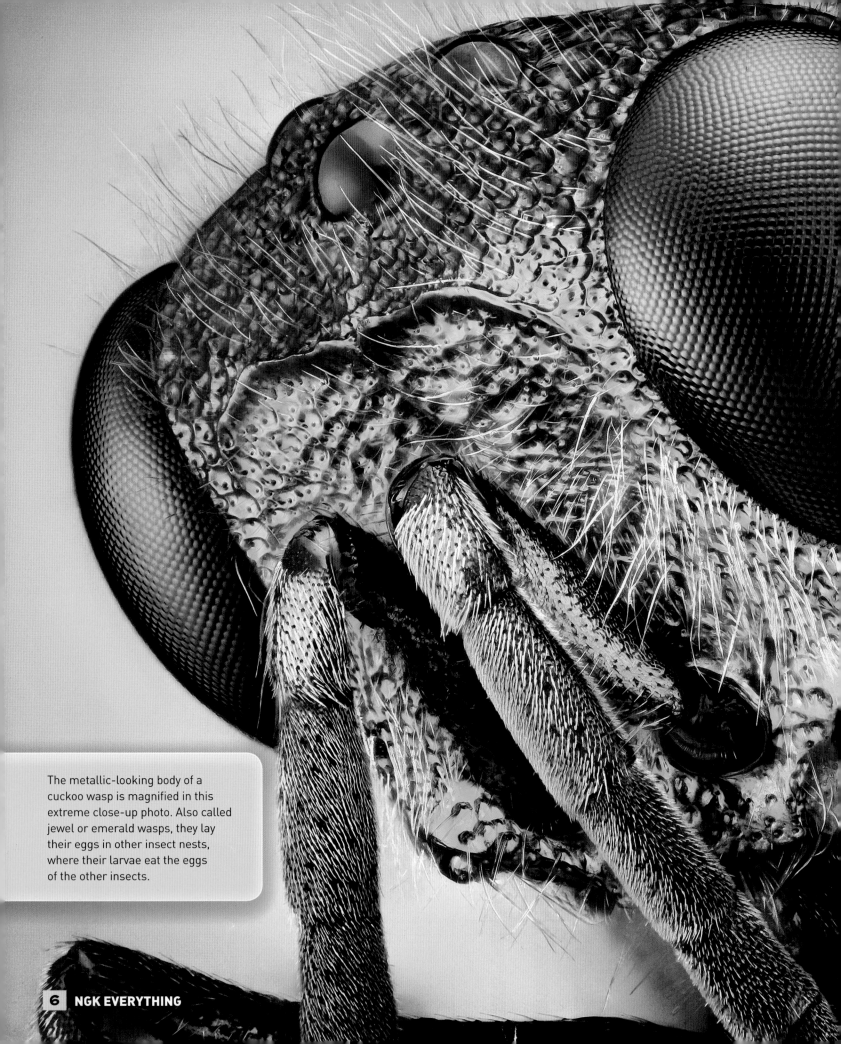

The metallic-looking body of a cuckoo wasp is magnified in this extreme close-up photo. Also called jewel or emerald wasps, they lay their eggs in other insect nests, where their larvae eat the eggs of the other insects.

# INTRODUCTION

## THEY'RE EVERYWHERE:
### ON EVERY CONTINENT, IN EVERY COUNTRY

and every city, schoolyard, backyard, even in our homes. They live inside, outside, up in the sky, in trees and plants, and under the ground. They are so numerous that scientists say they outnumber humans by 20 million to one.

They are insects. Some are brightly colored, while others are dull. Some have venomous stings; others are harmless. But all together, insects are an incredible group of animals that has been around much longer than people, even since before the dinosaurs! Insects are one of nature's greatest successes, which may surprise you, given their small size. All over the world, whether people consider them pests or helpers, insects play a big role in the planet's well-being. Ancient cultures admired them, Native Americans made them the stuff of legends and, even today, people in many parts of the world depend on them for food and to pollinate plants and flowers.

With about one million known species of insects on Earth, we have a lot of ground to cover. It's time to discover what all the buzz is about as you learn EVERYTHING about insects!

### EXPLORER'S CORNER

**Hi! I'm Dino J. Martins.**
I'm an entomologist—a scientist who studies insects. I do most of my work in Kenya. I work in different habitats, from the rain forests of western Kenya to the hot, dry deserts of Turkana in northern Kenya, and other places in East Africa. Working with farmers and kids, I teach the importance of insects as pollinators. Look for these Explorer's Corner boxes throughout the book, where I weigh in on how important insects are to our planet.

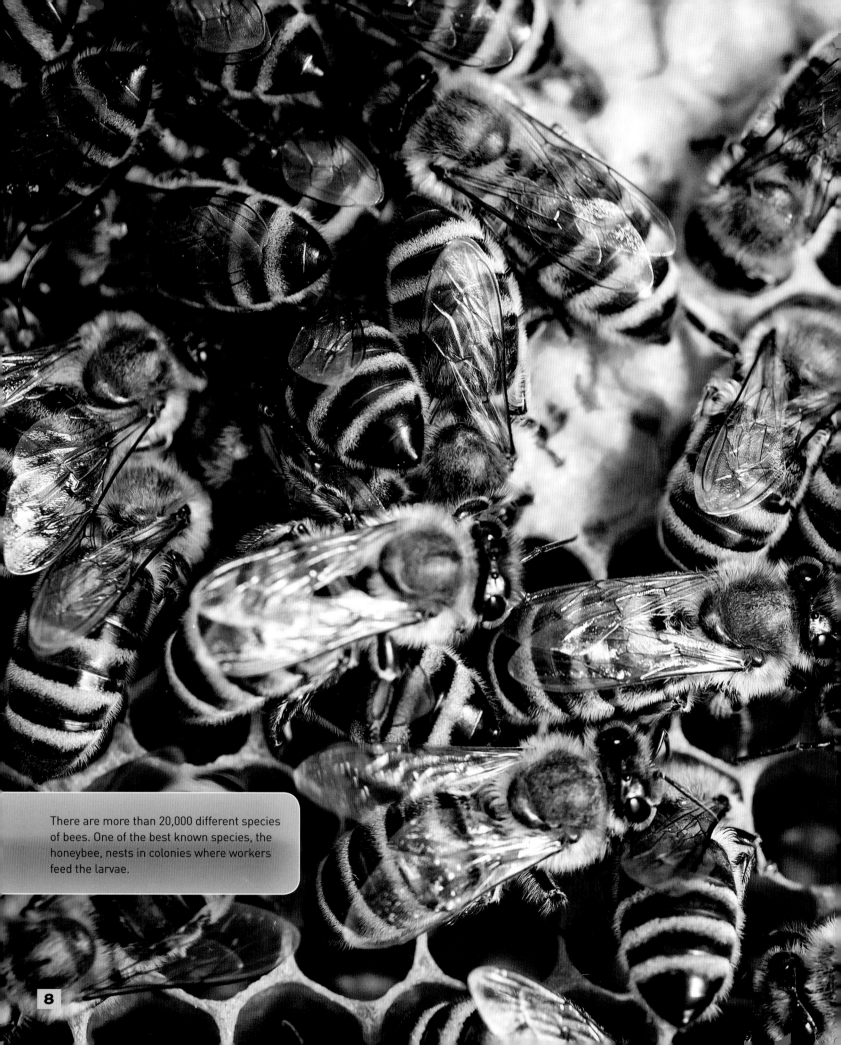

There are more than 20,000 different species of bees. One of the best known species, the honeybee, nests in colonies where workers feed the larvae.

# 1

# BRING ON THE INSECTS!

# WHAT IS AN INSECT?

## AH, OUR INSECT FRIENDS,

### THEY ARE HELPFUL (AND SOMETIMES HARMFUL).

They are also fun to watch, but can be creepy if they take you by surprise. The insect world is so diverse that it can be hard to determine what exactly is an insect.

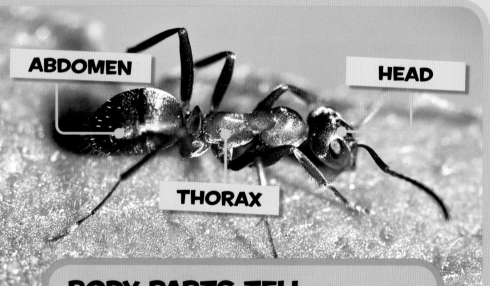

ABDOMEN

HEAD

THORAX

## BODY PARTS TELL THE STORY

All insect bodies are made up of three main parts: a head, a middle section called the thorax, and a rear section called the abdomen. All insects also have six legs. Many, but not all, insects have long, pointy sensors called antennae, plus one to two sets of wings. But that's where the similarities end.

## WAIT ... WHAT ARE BUGS THEN?

Not all insects are bugs. But all bugs are insects. Sounds confusing, right? To keep it straight, remember that "true bugs" are a group of insects that have specialized mouthparts designed for sucking up liquid (usually the sap of a plant, but sometimes blood). Aphids, cicadas, and water bugs are some examples of true bugs.

CICADA

**BUG BITE** THERE ARE AN ESTIMATED 10 QUINTILLION (10,000,000,000,000,000,000) INSECTS ON EARTH AT ANY GIVEN TIME.

**CATERPILLAR**

Many young insects look nothing like how they will look as adults. In fact, some look like tiny worms—but they are not related to worms at all!

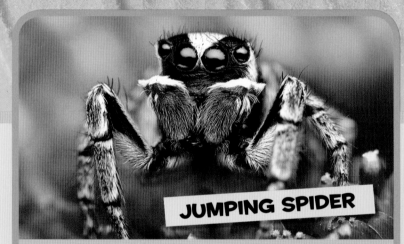

**JUMPING SPIDER**

## WHAT ISN'T AN INSECT?

Spiders are often thought of as insects, but they're not insects at all. They belong to a group of animals called arachnids. Spiders have eight legs instead of six and they never have wings. Sometimes the name of a creature can cause confusion. Pill bugs, for example, are neither bugs nor insects. They belong to a group of animals called crustaceans, as do lobsters and crabs. Centipedes and millipedes, those fast-moving, multi-legged critters that sometimes skitter out of drainpipes, aren't insects either. They are myriapods. However, all these animals are closely related to insects: Insects, arachnids, crustaceans, and myriapods all belong to a bigger group called arthropods. All arthropods, insects included, have a hard outer shell called an exoskeleton.

# By the Numbers

Insects are the largest group of animals on the planet. Here are the top five insect species by number.

**500,000** species of beetles are known to insect scientists.

**160,000** species of butterflies and moths flutter about the planet.

**140,000** species of ants, bees, and wasps help tidy Earth and pollinate plants.

**120,000** species of flies buzz around Earth.

**90,000** species of true bugs have been identified by scientists.

# INCREDIBLE INSECT AWARDS

## ALTHOUGH ALL INSECTS
### ARE INCREDIBLE IN THEIR OWN WAY, SOME

truly shine. Take some species of fireflies, for example. These flying insects actually make their own light! They do this by mixing oxygen with other substances in a special organ in their abdomen, which then glows. The ability of an animal to create its own light is called bioluminescence. Prepare to be wowed by these other stars of the insect world.

On long summer days, you'll hear them long before you see them: *Tsh-ee-EE-e-ou.* It's the sound of a male cicada trying to attract a female with his song. He makes the sound by rapidly moving drumlike membranes called tymbals in his abdomen. The sound is then amplified, or made louder, by air sacs in his body. The cicadas' song can reach 100 decibels, about as loud as a lawn mower, and can be heard from a quarter mile (400 m) away.

**LOUDEST**

**HEAVYWEIGHT**

**DEADLIEST**

The Actaeon beetle is the world's heaviest insect. In its larval (pre-adult) stage, it gorges on dead wood in the Amazon rain forest of South America. At seven ounces (200 g), the heavyweight larva tips the scales at about the same as an adult. That's two ounces (57 g) heavier than a baseball!

The deadliest insects in the world are several species of the *Anopheles* mosquito. While the mosquito bites alone are harmless, bites from females carrying a malaria-causing parasite can be deadly. Hundreds of thousands of people die each year from malaria.

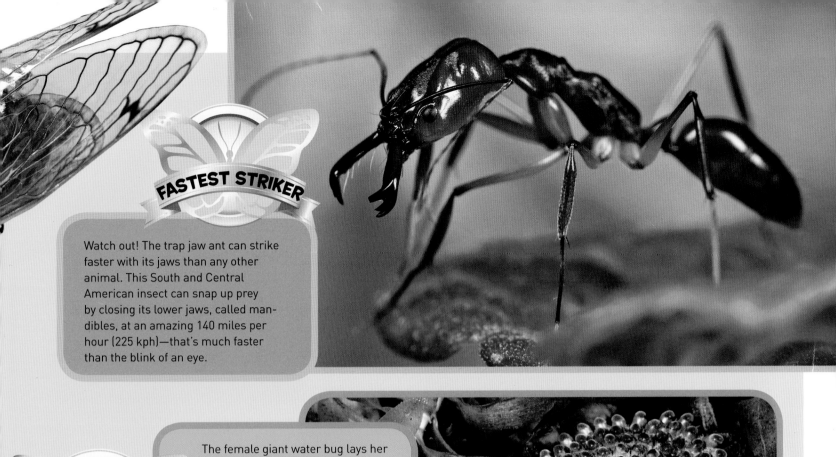

## FASTEST STRIKER

Watch out! The trap jaw ant can strike faster with its jaws than any other animal. This South and Central American insect can snap up prey by closing its lower jaws, called mandibles, at an amazing 140 miles per hour (225 kph)—that's much faster than the blink of an eye.

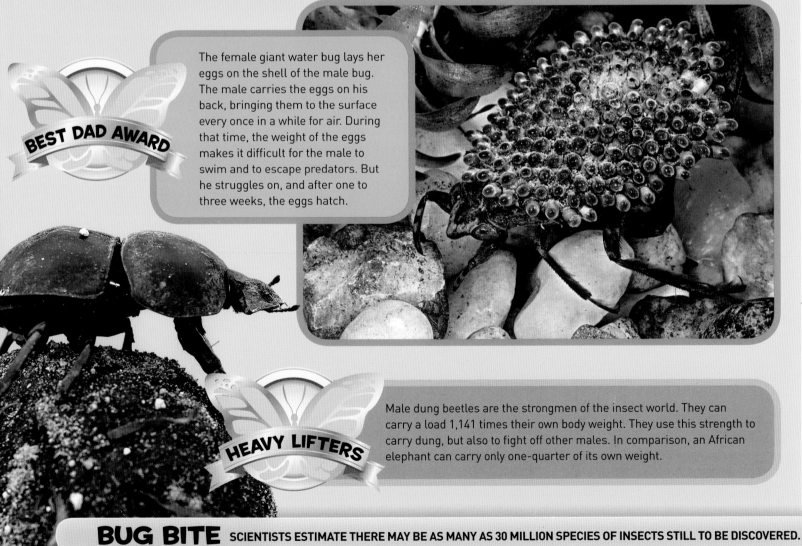

## BEST DAD AWARD

The female giant water bug lays her eggs on the shell of the male bug. The male carries the eggs on his back, bringing them to the surface every once in a while for air. During that time, the weight of the eggs makes it difficult for the male to swim and to escape predators. But he struggles on, and after one to three weeks, the eggs hatch.

## HEAVY LIFTERS

Male dung beetles are the strongmen of the insect world. They can carry a load 1,141 times their own body weight. They use this strength to carry dung, but also to fight off other males. In comparison, an African elephant can carry only one-quarter of its own weight.

**BUG BITE** SCIENTISTS ESTIMATE THERE MAY BE AS MANY AS 30 MILLION SPECIES OF INSECTS STILL TO BE DISCOVERED.

# LADIES AND GENTLEMEN: THE BEETLES!

## BEETLES ARE THE ROCK STARS

**OF THE INSECT WORLD. THEY ARE POPULAR AS** pets in some countries, jewelry in others, and even represented a god in ancient Egypt! Scientists estimate that beetles account for about one-quarter of all known animal species, and that many more species are still waiting to be discovered.

## WHERE DO BEETLES LIVE?

Beetles make their homes pretty much everywhere on Earth except Antarctica. They live on the ground in damp habitats, deserts, or rocky areas, where they eat worms, snails, and other small insects. Others are leaf beetles that eat plants. Leaf beetles are usually smaller than ground beetles, and are more brightly colored. There are even aquatic beetles that live in fresh water and swim using their strong hind legs.

**GREAT DIVING BEETLE**

**BUG BITE** SCIENTISTS WHO STUDY BEETLES ARE CALLED COLEOPTERISTS.

## IS THAT A BEETLE?

How will you identify a beetle when you see it? In addition to having the three insect body parts, adult beetles also have two sets of wings—light underwings used for flying, and hard wing covers called elytra. Look for the straight line down the middle of a beetle's back where the elytra wings meet.

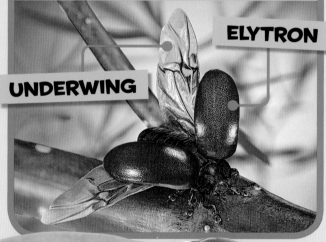

**ELYTRON**

**UNDERWING**

## LADYBUGS

Also called ladybird beetles, these yellow, pink, red, or orange insects with black spots are found all over the world. Farmers and gardeners often like ladybugs because most species are "helper insects" that eat other, crop-destroying insects.

## WEEVILS

Weevils are diverse and fascinating tiny beetles that are usually no more than 0.25 inches (6 mm) long. Most are considered pests because they eat farmers' crops. There are over 60,000 species of weevil and each has different habits and habitats. The giraffe weevil, from Madagascar, grows to be 1 inch (2.5 cm) long, and most of its size is taken up by a long neck that looks like a giraffe's neck.

**GIRAFFE WEEVIL**

Appetite alert! Weevils are sometimes found in breakfast cereals and flour. Grain or wheat weevils love to eat wheat products but cause no harm to humans if they are accidentally eaten.

## DUNG BEETLES

Some beetles eat leaves, some eat crops or other insects. Then there are the dung beetles. They eat animal feces, or poop or dung. They also lay their eggs in it, roll it, tunnel in it, and live in it. The dung provides a nutritious meal for the beetles, and the insects do the world a service by cleaning up the dung and making the soil fertile for plants by redistributing nutrients.

## HERCULES BEETLES

Hercules beetles get their name from their size and strength. These beetles can carry up to 850 times their own weight (a human can support only 17 times his or her own body weight). They are usually found on the ground in tropical rain forests of Central and South America, and some Caribbean islands. Male Hercules beetles can be up to 7.5 inches (19 cm) long—about the length of a new pencil. About half its length is taken up by long, hornlike pincers.

## EXPLORER'S CORNER

Mostly when we think of pollinators, we think of bees and butterflies. But beetles pitch in too! Beetles have been around for a very long time and they have developed special relationships with certain plants, which may have bigger flowers and stronger scents to attract these insects. In places of the world where bees are scarce, such as dry or arid regions, beetles do the work normally done by bees.

# INSECTS ON THE MOVE

NORTH AMERICA

MONARCH BUTTERFLIES

## INSECTS LIVE IN

**A VARIETY OF HABITATS—FROM** scorching hot deserts to freezing cold tundra, deep underground or in the highest mountains, and everywhere in between. Many insects spend their lives in one place. But some prefer travel. Check out these remarkable tales of insects on the move.

## MONARCH BUTTERFLY

### FLIGHT OF THE BUTTERFLIES

Every spring, massive colonies of monarch butterflies fly as many as 3,000 miles (4,800 km) from Mexico to Canada to lay their eggs on milkweed plants, which is the only food source for the monarch caterpillars. When the cold weather arrives, the butterflies fly south again. Two or three generations of butterflies may live and die over each summer. When the cold weather arrives, the last generation flies south again to their warm winter home.

EQUATOR

ARMY ANTS

SOUTH AMERICA

## BEE-WARE

Sometimes humans are responsible for insects being moved to somewhere new. Honeybees, for example, were brought to North America by settlers in the 1600s to produce honey. But there can be a downside to bringing foreign insects to a new home. In 1957, African honeybees were being studied at a research station in Brazil when they escaped and mated with European honeybees. Their offspring created a new species of bee called Africanized bees, or "killer bees." These bees then spread by about 250 miles (400 km) per year until the species reached the southern United States. They are considered a problem in many states because they are more aggressive than other bees.

## ARMY ANT

### THE ANTS GO MARCHING

Ants can be found almost everywhere on Earth. But the largest colonies of ants are the army ants of Central and South America and the driver ants of Africa. The Central and South American army ant, or *eciton Burchellii* species (shown on map), is the most studied army ant in the world. Given its raiding behavior, it was the first to be described by the term army ant. When a colony is on the move, it is called a column. In Africa, driver ant columns can be up to 300 feet (100 m) long and made up of about 20 million marching ants! Although the columns move at about a rate of only 46 feet (14 m) an hour, they will devour anything in their path, including venomous snakes and small mammals.

## LOCUST

### LOCUST SWARMS
When groups of locusts join together they become a swarm. Desert locusts in northern Africa, the Middle East, India, and Asia can form swarms that cover several hundred square miles, and contain billions of insects eating their body weight in food each day. Once the locusts have eaten all the vegetation, the swarm moves on. The swarm can travel anywhere from 3 to 80 miles (5 to 130 km) per day and devastate an area of plant life.

### LOCUST MIGRATION
When searching for new food sources, adult Australian plague locusts take advantage of warm but strong storm winds. They ride the winds to migrate from one area to another, taking off at dusk and flying up to ten hours and several hundred miles at a time. This long-distance migration allows Australian plague locusts to survive in harsh environments. When many swarms group together, they are considered a plague because they can eat up to 2,204 pounds (1,000 kg) of vegetation and food crops per day.

EUROPE

ASIA

LOCUSTS

AFRICA

DRAGONFLIES

AUSTRALIA

LOCUSTS

### DRAGONFLY DIRECT
Globe skimmers hold the record for the longest migration of any insect. Carried by strong winds, these dragonflies travel from India to East and southern Africa and back again, a journey of about 8,700 to 11,000 miles (14,000 to 18,000 km), much of it over the Indian Ocean.

DRAGONFLY

ANTARCTICA

| 0 | 2,000 miles |
| 0 | 2,000 kilometers |

**BUG BITE** THE ONLY INSECT THAT LIVES IN ANTARCTICA IS A WINGLESS MIDGE (A TYPE OF TINY FLY) NAMED *BELGICA ANTARCTICA*.

# A PHOTOGRAPHIC DIAGRAM

## BODY PARTS

## INSECTS—*BUG*-LY OR *BEE*-UTIFUL? BEAUTY IS IN THE EYE OF THE BEE-HOLDER, BUT IT CAN BE DIFFICULT TO BEHOLD

when your subject flits, fidgets, and quickly scatters. Insects always seem to be flying, moving, or hiding. Luckily, these close-up photographs give us a good look at insect bodies. But you can also take out a magnifying glass and try to get a good look at live insects up close and in person.

## WINGS

Some insects have four wings, others have two or none at all. Insects are champion fliers—they can move forward, backward, sideways, and some can even hover in place. Research shows bees flap their wings an amazing 230 times a second.

## ABDOMEN

The rear body part of an insect is called the abdomen.

## EXOSKELETON

Insects have a hard outer covering called an exoskeleton that protects their internal organs and supports their muscles. Exoskeletons are made up of separate plates with a soft material in between that allows the insect to move its legs.

## OVIPOSITOR

Some female insects have an ovipositor on their abdomen. This organ is used for laying eggs. It can also be used for stinging, in the case of bees and wasps.

## LEGS

Insects have six legs—three on either side of the body. Claws on the ends of the legs are used for gripping when climbing or walking. Between the claws are sticky sacs that help insects cross smooth surfaces. Monarch butterflies taste with the tips of some of their legs. Dung beetles use their front legs like shovels. Some insects, such as grasshoppers, have powerful back legs for jumping.

## ANTENNAE

Almost all insects have two antennae. Their length and shape depend on their use, which could be to break up prey, detect odors, or find food. Male mosquitoes have feathery antennae to detect the humming wings of females. Cockroaches have long antennae used to feel things around them.

## HEAD

The head is the first of an insect's three main body sections. It's here that an insect's eyes, mouthparts, and antennae (for those insects that have them) are located.

## EYES

Many insects have large compound eyes that detect motion. Compound eyes are made up of up to 30,000 specialized lenses called ommatidia.

## BUTTERFLY

## THORAX

The thorax is the middle section of an insect, after the head. The legs and wings are usually found here.

## MOUTHPARTS

Mouthparts are specialized, depending on the food an insect eats. Many chewing insects have mouthparts that are made up of a pair of jaws, called mandibles, with teeth. Some also have lips and palps that taste food on either side of their jaws. Many butterflies and moths have long, tube-like mouthparts called a proboscis, used to suck up liquid.

## HAIR

Hair on some insect bodies acts as motion detectors so insects can sense what's around them. Some caterpillars have poison-filled hairs that protect them from predators.

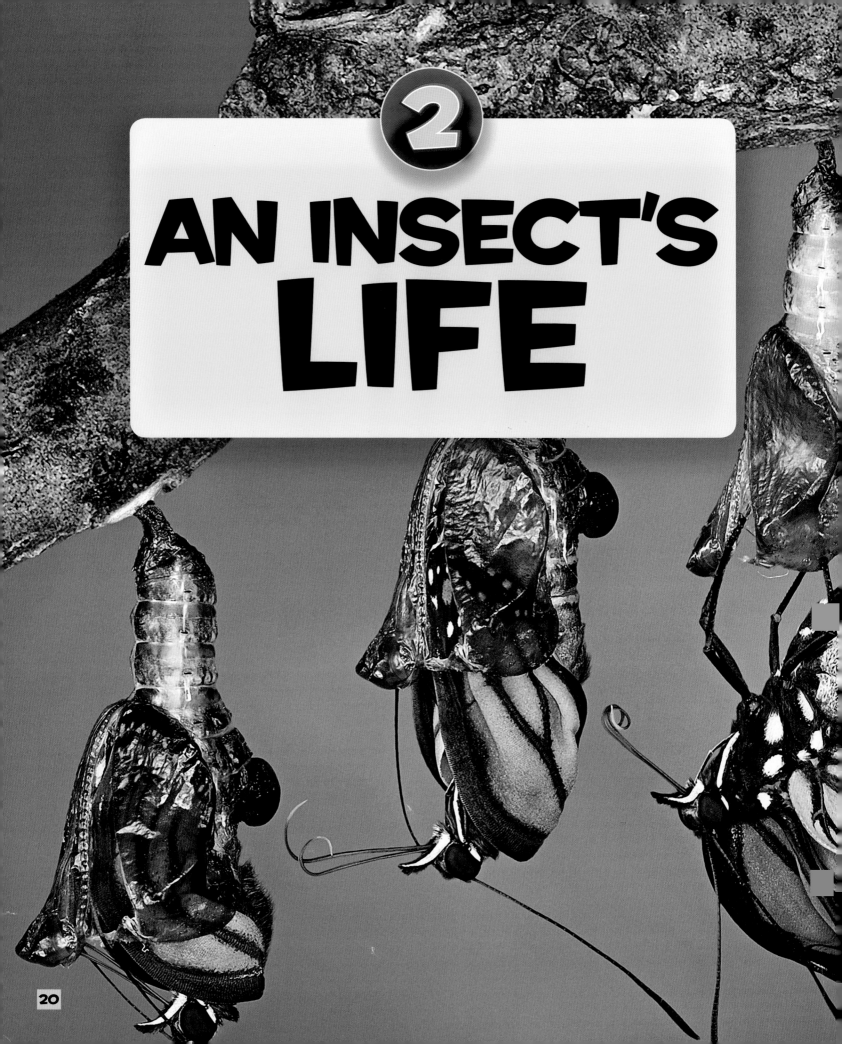

# AN INSECT'S LIFE

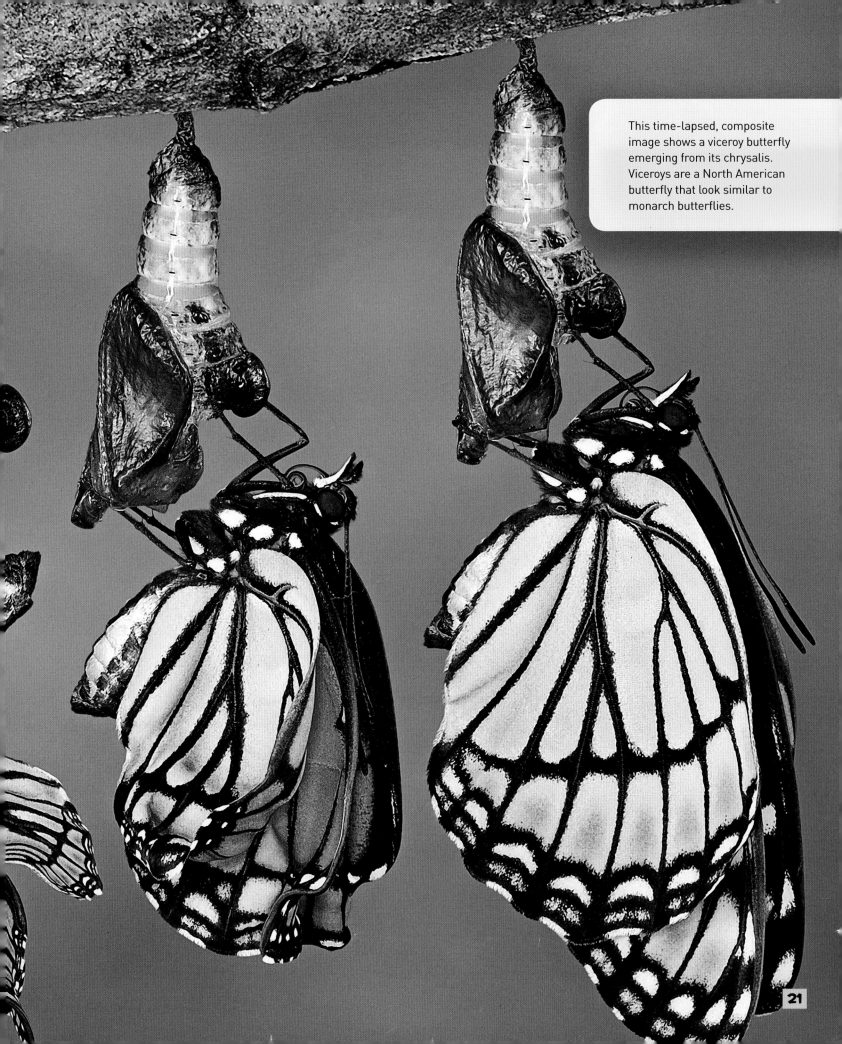

This time-lapsed, composite image shows a viceroy butterfly emerging from its chrysalis. Viceroys are a North American butterfly that look similar to monarch butterflies.

# EGGS TO ADULTS

## WHETHER AN INSECT LIVES FOR JUST ONE

**DAY (THE LIFE SPAN OF A MAYFLY) OR FOR 50 YEARS (THE LIFE SPAN OF** an African termite queen), its body undergoes a remarkable transformation from birth to adult. This change is called metamorphosis. There are two different kinds of metamorphosis: complete and incomplete.

## COMPLETE METAMORPHOSIS

### 1. EGG
Most insects begin life as an egg. Eggs are laid singularly or in clusters of hundreds. Female insects lay eggs in areas where there is food for the larvae when they hatch. Some insect larvae have a specialized organ on their heads called an egg buster. They use the egg buster to crack open their shell.

### 3. PUPA
In the pupal stage, the insect's body breaks down and reforms into its adult shape. During this period it does not eat, and it is usually found wrapped in a protective case, or cocoon, in a safe hiding place.

### 4. ADULT
When an insect emerges from the cocoon, it is an adult. Adults live from just a few days in some species to many years in others.

### 2. LARVA
Larvae often look like worms. They can be called caterpillars (butterflies and moths), maggots (flies), or grubs (beetles). Larvae usually eat different food than the adult. Their main purpose is to eat and store energy for the next stage. During that time, they may molt, or shed their skin, several times.

The giant peacock moth is the largest moth or butterfly in Europe. It has a wingspan of four to eight inches (10 to 20 cm).

**BUG BITE** MALE GRASSHOPPERS USE AN ORGAN AT THE BASE OF THEIR WINGS TO "CHIRP" TO ATTRACT A MATE.

# INCOMPLETE METAMORPHOSIS

## 1. EGG

Eggs are laid singularly or in clusters near a food source or in an environment, such as on a plant near water, that is suitable for the longer nymph stage of life. In some insects that undergo incomplete metamorphosis, the eggs mature inside the female's body. They are then carried around in a capsule on the female's body and are born from the capsule.

## 2. NYMPH

Nymphs are young insects. Their exoskeletons don't grow as the insect does, so when the insect gets too big for its skin, it molts, or sheds—from 4 to 20 times.

## 3. ADULT

In most insects that undergo incomplete metamorphosis, nymphs look much like the adults, except the adults are larger and have fully formed wings.

**DRAGONFLY**

# By the Numbers

**4,000,000** eggs are laid by an African driver ant queen every 25 days.

**600,000** eggs can be laid by a queen bee in her lifetime.

**30,000** eggs are laid by a termite per day.

**9,000** eggs are laid by a housefly in her lifetime.

**30** eggs are laid by a stag beetle in her lifetime.

## MATING

Most insects mate to produce offspring. They use many tricks and techniques to attract a mate, from "singing," to fighting or flashing brightly colored wings. Usually a female and a male are needed to reproduce, but there are some exceptions. For example, cabbage aphids and some stick insects can reproduce on their own in a process called parthenogenesis.

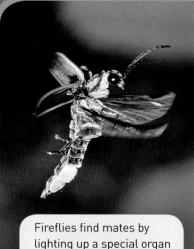

Fireflies find mates by lighting up a special organ in their abdomens.

# PARDON MY PUPAE

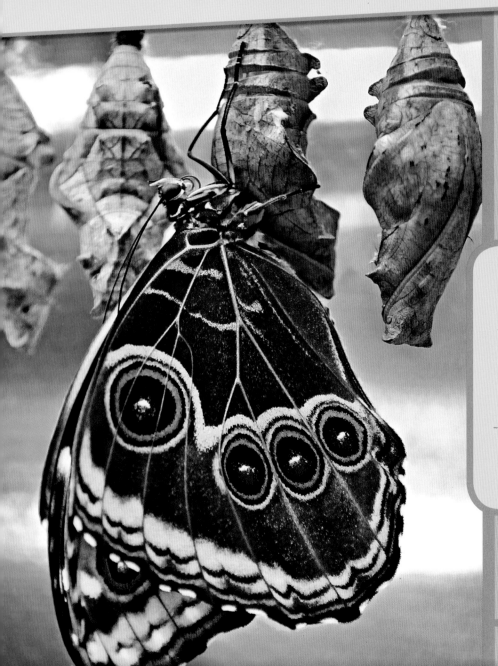

## IF INSECTS MATURED
### LIKE HUMANS, THE PUPAL STAGE

would be like the teen years—an intense period with wild growth spurts, time spent alone, and miraculous transformations. And just like it is in moody teenagers, this stage is ruled by hormones, or chemicals produced by glands in the body that affect behavior and changes in the body.

## HOME SWEET COCOON

Have you ever built yourself a protective hideout with blankets and pillows? You might have called it your "cocoon." Some insects make cocoons to protect themselves while their bodies are forming into adults. Butterflies and moths make cocoons, as do beetles, flies, bees, and wasps. Insect larvae make cocoons using a silklike thread produced from glands on their bodies. Some spin the silk in a figure-eight pattern and encase themselves. When the silk comes into contact with the air, it begins to harden.

THE PUPAE OF SOCIAL INSECTS, SUCH AS MANY BEE SPECIES, ARE PROTECTED BY THE ADULTS OF THE HIVE.

**BUG BITE** ANT PUPAE CAN PRODUCE SOUND TO COMMUNICATE WITH THE OTHER ANTS IN THE COLONY.

# PUPAE PROTECTION

A cocoon is like a tent—it may keep the rain and wind out, but it might not prevent a hungry predator from getting inside. Some insect species have developed clever pupae protection strategies. Blue butterflies trick ants into looking after them during the pupal stage. The butterfly larva releases chemicals called pheromones that make the ants believe it is one of their larvae. The ants take the cocoon back to their underground nest and care for it until the butterfly is ready to emerge.

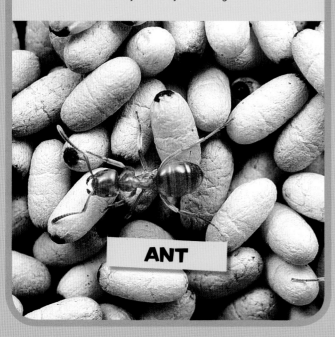

ANT

# CATERPILLAR TO BUTTERFLY

One day you're a wormlike caterpillar and the next (well actually, weeks, months, or sometimes years later) you're a beautiful, winged butterfly or moth. This complete overhaul from pupa to adult involves time spent in a cocoon, or chrysalis. The word "chrysalis" comes from the Greek word for "gold"—since many butterfly pupae have a gold tint.

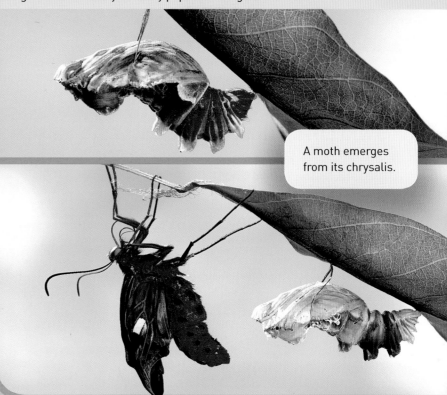

A moth emerges from its chrysalis.

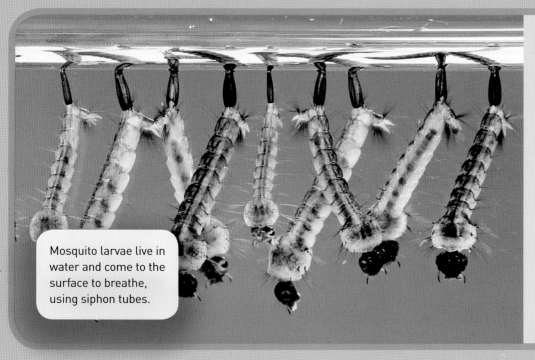

Mosquito larvae live in water and come to the surface to breathe, using siphon tubes.

# UNDERGROUND, UNDERWATER, UNDER WHERE?

Many butterfly and moth cocoons hang from the undersides of branches by a hook in the pupa's body called a cremaster. Other moths, such as the hummingbird moth, have larvae that dig underground to build their cocoons. Stag beetles also have underground cocoons, and bark beetles build their cocoons under tree bark. Caddisflies (or sedges), mosquitoes, and blackflies build their cocoons underwater.

# FEASTING AND FORAGING

## THEY CHOMP, THEY SUCK, THEY SWALLOW THINGS WHOLE. INSECTS WOULD MAKE AMAZING

dinner guests because they almost never turn down a meal. They also eat a variety of foods from poop to plants to each other.

## JAW-DROPPING APPETITE

Some insects are known for their ability to eat a lot of food. Locusts can eat their own weight in plants every day. This makes a swarm, or plague, of locusts dangerous for farmers. They can tear through a field in no time—leaving just stalks behind. Silkworms, the caterpillar of the *Bombyx mori* moth, also have healthy appetites. They can eat their weight in mulberry tree leaves in a day. Insects that eat plants and other insects have mouthparts called mandibles. These are strong jaws used for tearing and grinding food.

A plague of locusts lands on a farmer's field, ready to eat through the crop.

**BUG BITE** THERE ARE ABOUT TEN SPECIES OF MOTHS THAT DRINK THE TEARS OF ANIMALS FOR NUTRIENTS.

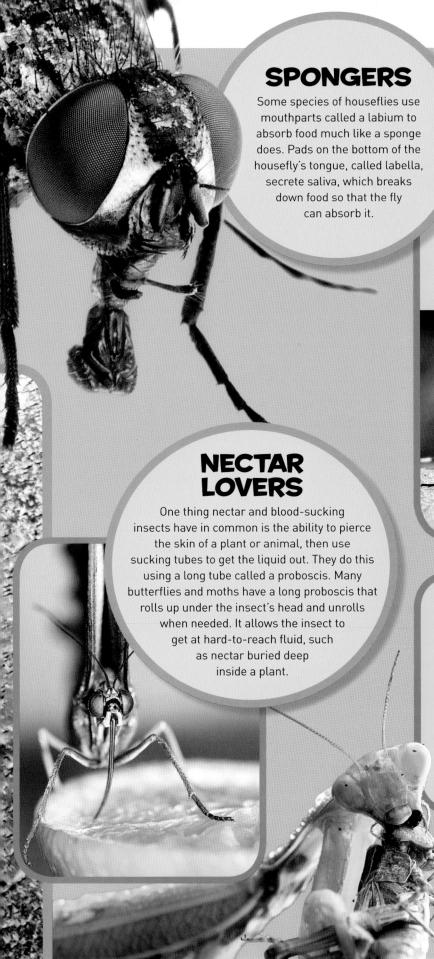

## SPONGERS

Some species of houseflies use mouthparts called a labium to absorb food much like a sponge does. Pads on the bottom of the housefly's tongue, called labella, secrete saliva, which breaks down food so that the fly can absorb it.

## I VANT TO SUCK YOUR BLOOD

Fleas, lice, bedbugs, some flies, and female mosquitoes are famous bloodsuckers. They feed on human and other animal blood. Some insects need the blood to produce eggs. Bloodsuckers are annoying and some, including certain species of mosquitoes, can also transmit diseases such as malaria, yellow fever, and West Nile virus.

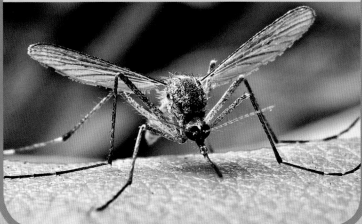

## NECTAR LOVERS

One thing nectar and blood-sucking insects have in common is the ability to pierce the skin of a plant or animal, then use sucking tubes to get the liquid out. They do this using a long tube called a proboscis. Many butterflies and moths have a long proboscis that rolls up under the insect's head and unrolls when needed. It allows the insect to get at hard-to-reach fluid, such as nectar buried deep inside a plant.

## HUNGRY ANYONE?

Insects as a whole will eat virtually anything, but some types are specialists. Flies and dung beetles are particularly partial to poop, or the half-digested food in bird or other animal poop. Honeypot ant colonies have specialized worker ants in the colony whose job it is to gorge on food until their abdomens swell with a honeylike substance. They then hang from the ceiling of the nest. When food is scarce, the other ants will eat from this store. And of course, some insects eat other insects. Mantises like to ambush their prey, usually eating the head first before moving on to the rest of the body.

**SOME ADULT INSECTS DO NOT HAVE MOUTHPARTS AND EAT NOTHING AT ALL.**

# INSECT HOMES

## INSECTS ARE NOT HARD TO FIND. IF YOU LOOK, YOU WILL SEE THEM CRAWLING ON THE GROUND, RESTING ON PLANTS, OR

flying through the air. Some flying insects, such as dragonflies, butterflies, and moths, have no permanent home, choosing instead to flit from place to place. But others build impressive structures as nests, or make their homes on other animals.

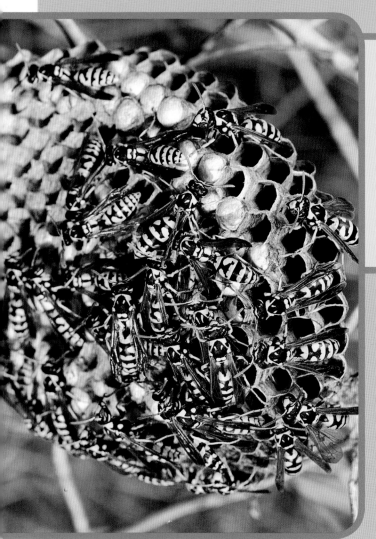

## LIVING AND WORKING TOGETHER

While most insects prefer to be on their own, others live together in colonies or nests. These insects are called social insects. Wasps, bees, ants, and termites are examples of social insects that work together to build nests. Paper wasps collect wood and plant fibers, and mix them with saliva to create paperlike nests that hang from tree branches. Bees create nests using a wax that they secrete, usually high up in cavities in trees. Ants build underground nests with several different chambers, or rooms. Some ants even create living nests out of their own bodies. These nests are called bivouacs. Termites create giant mounds made of dirt, wood, mud, and poop. The shape of these structures allows for air flow that regulates the temperature within.

## OUR HOME IS THEIR HOME

We don't usually invite insects into our homes, but they come in anyway. Many are considered household pests. The most unwanted insect guests are cockroaches. They make their homes in cracks in walls or under sinks and furniture. Cockroaches become a problem for homeowners because they multiply quickly, require little food to survive, and are expert hiders. Another insect that occasionally shares our homes are bedbugs that live in our beds and come out to feed on our blood at night. There's even a type of beetle that lives in carpets.

**BUG BITE** WEAVER ANTS BUILD NESTS BY GLUING LEAVES TOGETHER USING SILK MADE BY THEIR LARVAE.

## LIVING IN WATER

Some insects make their homes in water. But all insects need to breathe air to survive, so they have adapted some pretty cool ways of living in their watery habitats. Mosquito larvae float just under the water's surface and stick up little tubes to breathe. Other insects have gills, or organs that allow them to filter oxygen from the water into their bodies. Diving beetles carry air from the surface in sacs or bubbles so they can breathe underwater.

The family that dives together thrives together. This diving beetle is carrying its eggs on its back.

**DIVING BEETLE**

Monarch butterflies hibernate on a forest tree in Mexico.

FLEAS MAKE THEIR HOME ON A HOST, SUCH AS A DOG, AND THEIR SURROUNDINGS—INCLUDING YOUR RUGS!

## EXPLORER'S CORNER

Insects need safe homes too! Protecting and providing places for bees to nest is one of the best ways of making sure that they can visit flowers and pollinate crops. Most solitary bees nest in holes in dry wood or the ground.

## WINTER HOMES

Insects are only as warm as their surroundings. To survive the cold winter or a dry season, some insects migrate to other climates. Others burrow underground. Some hibernate during the winter by finding a sheltered place and clustering together.

# A PHOTO GALLERY

**HUNDREDS, IF NOT THOUSANDS, OF** insects are hanging out in your backyard or local park right now. You can't see them all because they are small, and some have natural camouflage that allows them to blend into their surroundings. Can you find the insects in these photos?

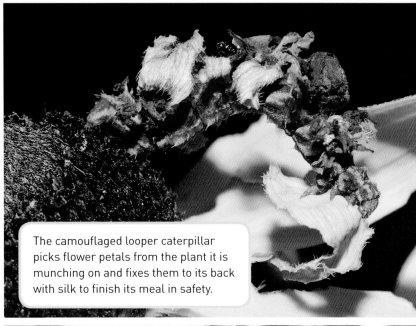

The camouflaged looper caterpillar picks flower petals from the plant it is munching on and fixes them to its back with silk to finish its meal in safety.

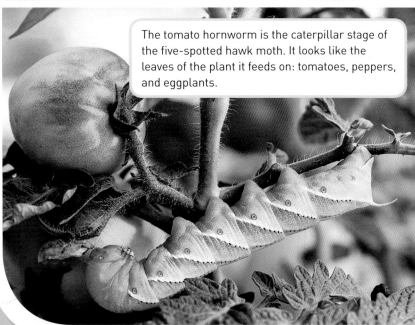

The tomato hornworm is the caterpillar stage of the five-spotted hawk moth. It looks like the leaves of the plant it feeds on: tomatoes, peppers, and eggplants.

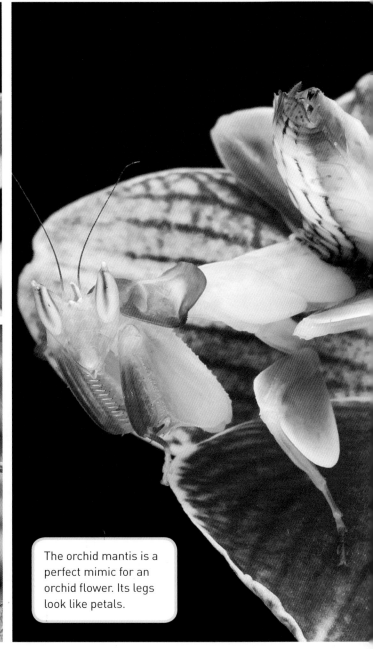

The orchid mantis is a perfect mimic for an orchid flower. Its legs look like petals.

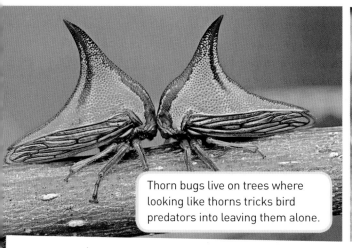

Thorn bugs live on trees where looking like thorns tricks bird predators into leaving them alone.

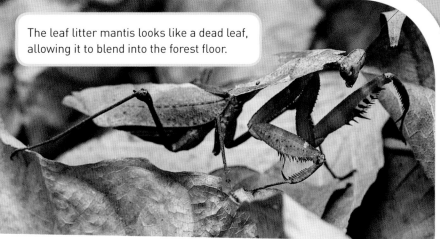

The leaf litter mantis looks like a dead leaf, allowing it to blend into the forest floor.

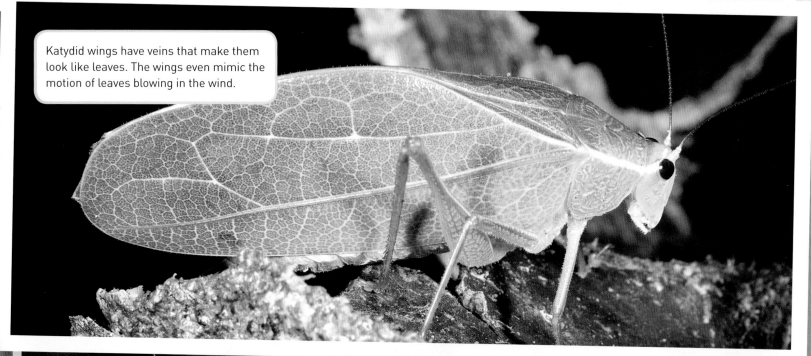

Katydid wings have veins that make them look like leaves. The wings even mimic the motion of leaves blowing in the wind.

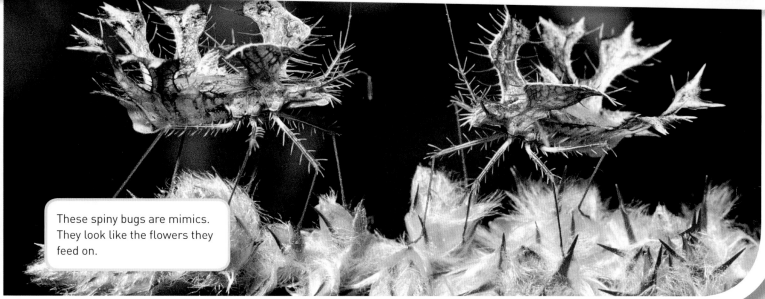

These spiny bugs are mimics. They look like the flowers they feed on.

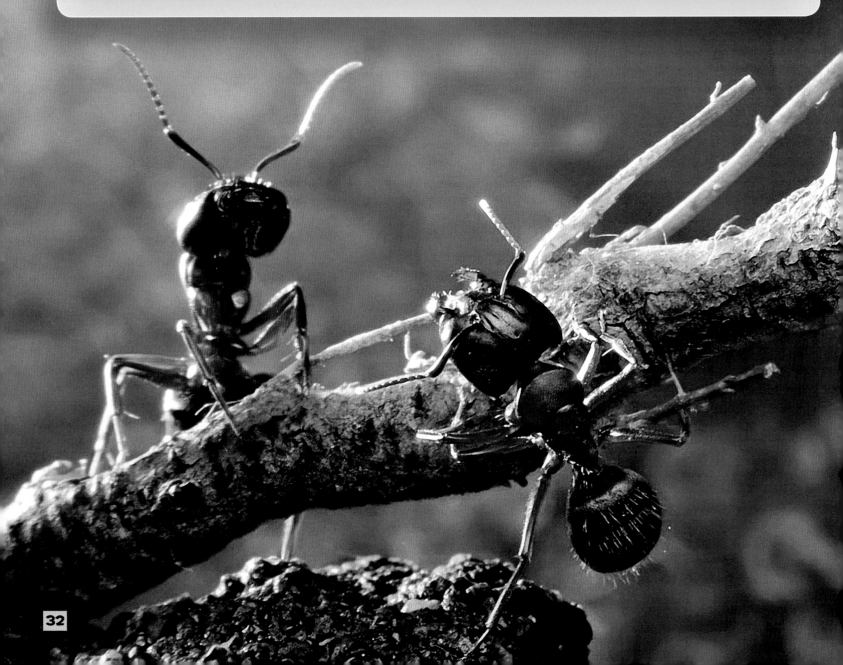

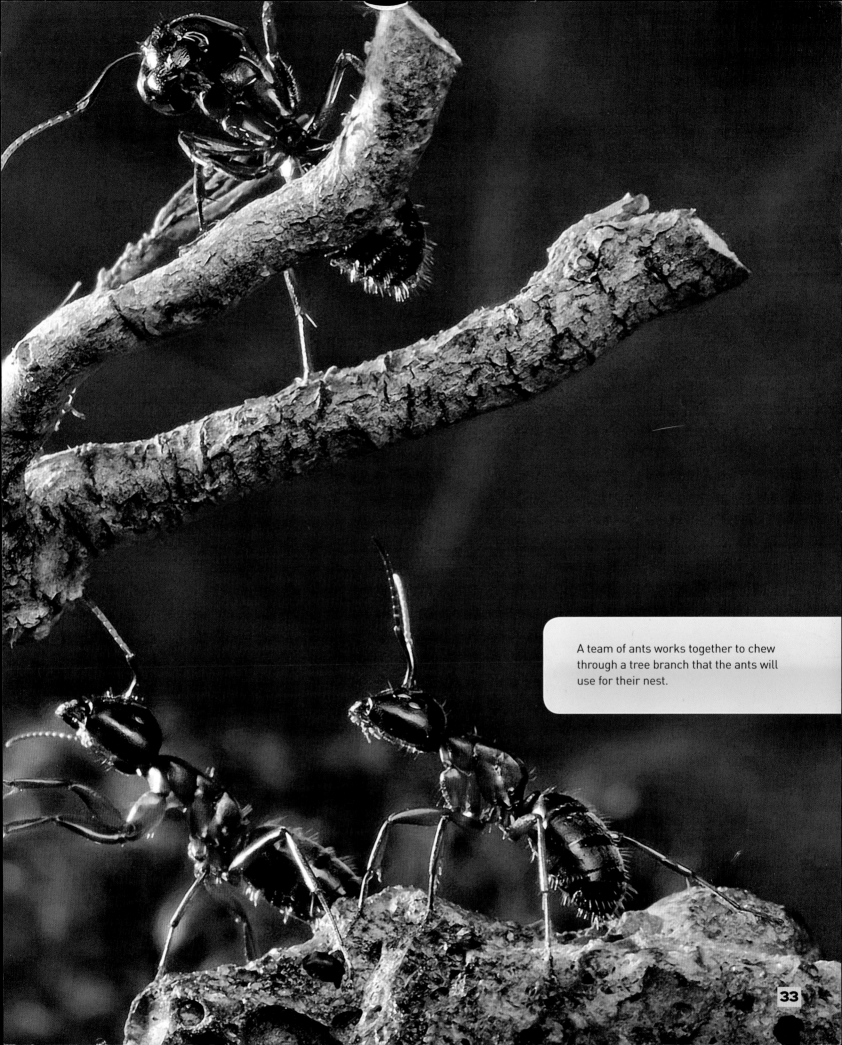

A team of ants works together to chew through a tree branch that the ants will use for their nest.

33

# INSECT RELATIVES

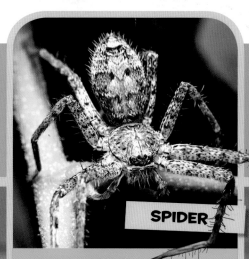

SPIDER

## CREEPY COUSINS

Spiders are often mistaken as insects, but they belong to a group of animals called arachnids. Spiders have eight legs and no antennae. They have two body parts. The front part, called the cephalothorax, is where the eyes, mouthparts, and legs are. The rear body part—the abdomen—is where their webmaking silk glands are found.

## INSECTS ARE PART OF A LARGER

**GROUP OF ANIMALS CALLED ARTHROPODS. NOW IMAGINE** an arthropod family reunion where thousands of cousins are gathered together. The differences in appearance and behavior would boggle the mind. Spiders, crabs, lobsters, and many other animals are arthropods. Arthropods all share at least one common characteristic: they have exoskeletons, or skeletons outside their body rather than bones within.

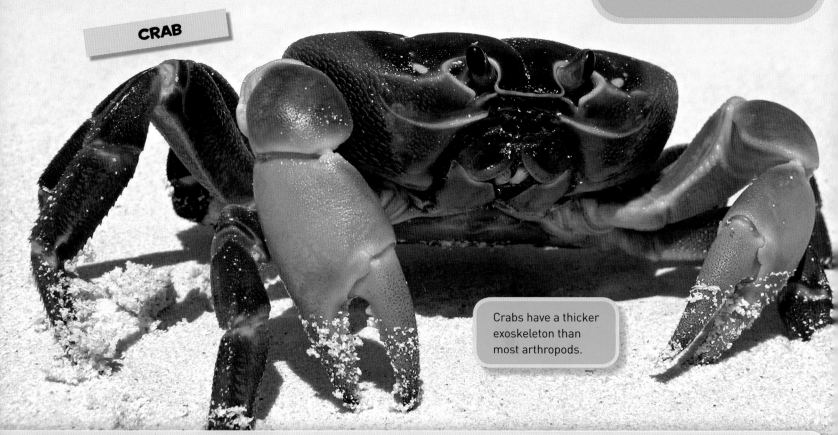

CRAB

Crabs have a thicker exoskeleton than most arthropods.

**BUG BITE** THE WORD "INSECT" COMES FROM THE LATIN WORD *INSECTUM* AND REFERS TO AN INSECT'S THREE BODY SEGMENTS.

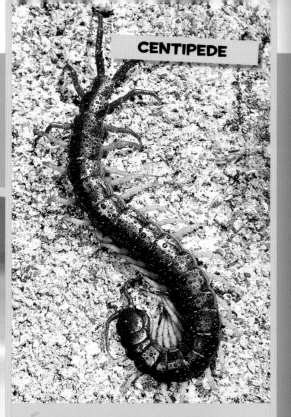

CENTIPEDE

## LOTS OF LEGS

You know those creepy things that sometimes quickly skitter around your bathroom sink and seem to have a hundred legs? They are not insects, but they are related. They are called myriapods. Centipedes and millipedes are myriapods. They have long, wormlike bodies and as many as 400 legs. Their bodies are made up of many segments, or parts. The largest centipede is found in the West Indies and grows to 12 inches (30 cm) long. Centipedes eat insects, which is a good thing. It helps keep insects from taking over Earth!

## ROLY POLIES

What has seven pairs of legs, two antennae, two eyes, and rolls into a ball when frightened? Pill bugs, or roly polies, are another creepy-crawly often mistaken for an insect. They are crustaceans that need moisture to live, meaning you may come across them under decaying leaves, bark, or in a damp basement.

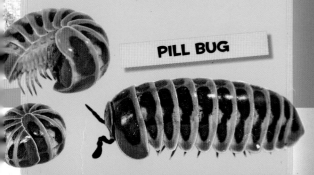

PILL BUG

# THE ANIMAL KINGDOM

The animal kingdom isn't really a kingdom with a ruler. It's a way scientists classify, or group, living things and how they relate to each other. There are millions of animal species in the world. When you are dealing with that many, it makes sense to organize and categorize them into groups and subgroups. All animals, including humans and insects, belong to the animal kingdom. The animal kingdom is further divided into two main groups—those with backbones (vertebrates) and those without (invertebrates). Insects and their relatives are invertebrates.

## THE INSECT FAMILY TREE

The insect class is further broken down into orders. There are 32 different orders of insects. Here are the main orders and the common names of the insects within them.

**DIPTERA**
flies

**COLEOPTERA**
beetles

**DICTYOPTERA**
mantises, cockroaches, and termites

**LEPIDOPTERA**
butterflies and moths

**HYMENOPTERA**
ants, bees, and wasps

**ODONATA**
dragonflies and damselflies

**EPHEMEROPTERA**
mayflies

**PHASMIDA**
stick insects

**HEMIPTERA**
cicadas, aphids, and true bugs

**ORTHOPTERA**
grasshoppers and katydids

# ANCIENT INSECTS

This art shows giant insects and an arachnid of the Carboniferous period.

## INSECTS HAVE BEEN

**AROUND SINCE BEFORE THE TIME** of dinosaurs. Scientists aren't exactly sure what the first insect was, or when it appeared. This is because, without internal bones, insect bodies cannot turn into fossils. The fossil records that do exist are impressions of insects in stone or other hardened material, or insect bodies found trapped in tree sap, or amber.

## REALLY OLD

So far, the oldest known insect is the *Rhyniognatha*, from about 400 million years ago. Only its mandibles (jaws) have been preserved and, from these, paleoentomologists—scientists who study fossilized insect records—believe it was a plant-eater. Though plants had been around before the first insect, their adaptation and spread made it possible for prehistoric insects to thrive, because they had a hearty food source. Insect relatives, such as scorpions, spiders, and centipedes, were also around at that time.

ANCIENT COCKROACHES ARE NEARLY IDENTICAL TO COCKROACHES TODAY.

**BUG BITE** INSECTS HAVE BEEN AROUND TWICE AS LONG AS REPTILES AND SEVEN TIMES AS LONG AS HUMANS.

# EEK, CARBONIFEROUS COCKROACH!

Cockroaches are some of the oldest known species of insect. They have been around since at least 315 million years ago, during a period known as the Carboniferous period. And they were huge! It was also during that time of large and lush forests and swamps that the first flying insects appeared. And they grew to monstrous sizes too! The largest flying insect of the time was a dragonfly called *Meganeuropsis permiana*, with a wingspan of about 27 inches (70 cm) and a body 17 inches (43 cm) long. It may have fed on other insects and small amphibians. There are different theories as to why many ancient insects got to be so large. One is that there was more oxygen in the air and more oxygen means plants and animals grow bigger. Carboniferous insects had larger breathing systems to supply air to their larger bodies.

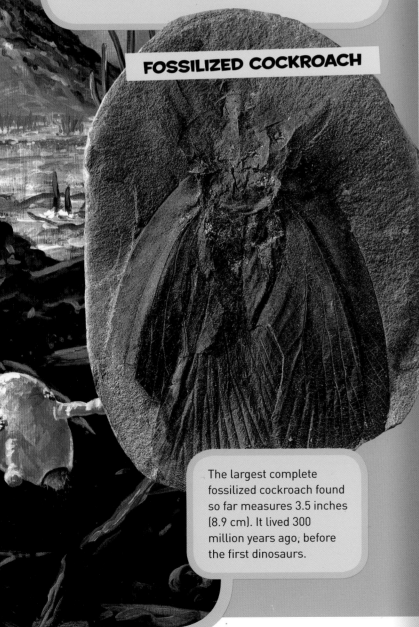

**FOSSILIZED COCKROACH**

The largest complete fossilized cockroach found so far measures 3.5 inches (8.9 cm). It lived 300 million years ago, before the first dinosaurs.

# ANCIENT EARTH

The history of Earth is broken up into different periods when great changes occurred. Here's where insects fit in with the origins of life on Earth.

**PRECAMBRIAN**
4.6 billion years ago–570 million years ago (m.y.a.) single-celled organisms

**CAMBRIAN**
570–500 m.y.a. creatures with skeletons

**ORDOVICIAN**
500–435 m.y.a. fish and plants

**SILURIAN**
435–410 m.y.a. land creatures

**DEVONIAN**
410–360 m.y.a. amphibians

**CARBONIFEROUS**
360–290 m.y.a. flying insects

**PERMIAN**
290–248 m.y.a. swimming reptiles

**TRIASSIC**
248–205 m.y.a. dinosaurs

**JURASSIC**
205–138 m.y.a. mammals, birds

**CRETACEOUS**
138–63 m.y.a. flowering plants

**PALEOGENE**
63–24 m.y.a. primates

**NEOGENE**
24–2 m.y.a. hominins

**QUATERNARY**
2 m.y.a.–present modern humans

**PRECAMBRIAN SINGLE-CELLED ORGANISM**

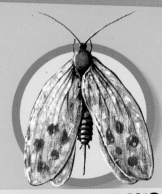

**CARBONIFEROUS FLYING INSECT**

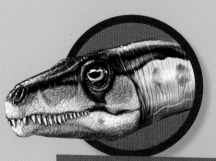

**TRIASSIC EORAPTOR**

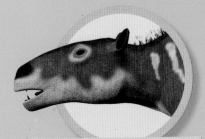

**PALEOGENE EUROHIPPUS**

# SURVIVAL OF THE FITTEST

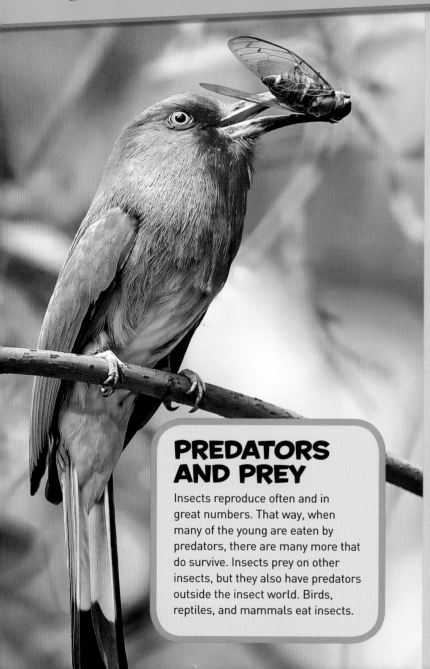

## THE SMALLEST INSECTS
### ARE SO TINY THEY CANNOT BE SEEN

with the naked eye. You might think that insects are at a disadvantage because they are small, but their size is one of the reasons they are so successful at staying alive and reproducing. They can easily find places to live and small spaces to hide from predators, such as under tree bark or rocks.

LADYBUG

## PREDATORS AND PREY

Insects reproduce often and in great numbers. That way, when many of the young are eaten by predators, there are many more that do survive. Insects prey on other insects, but they also have predators outside the insect world. Birds, reptiles, and mammals eat insects.

## CHEMICAL WARFARE

Some insects have defenses built right in. For example, some caterpillars use other animals for defense. They create a fluid that attracts ants. If a predator tries to attack the caterpillar, the ants will fight it off. When ladybugs are threatened, they leak yellow blood from their leg joints that smells bad and contains poison.

**BUG BITE** SOME ASSASSIN BUGS SHOOT VENOM AT A PREDATOR'S EYES AND NOSE.

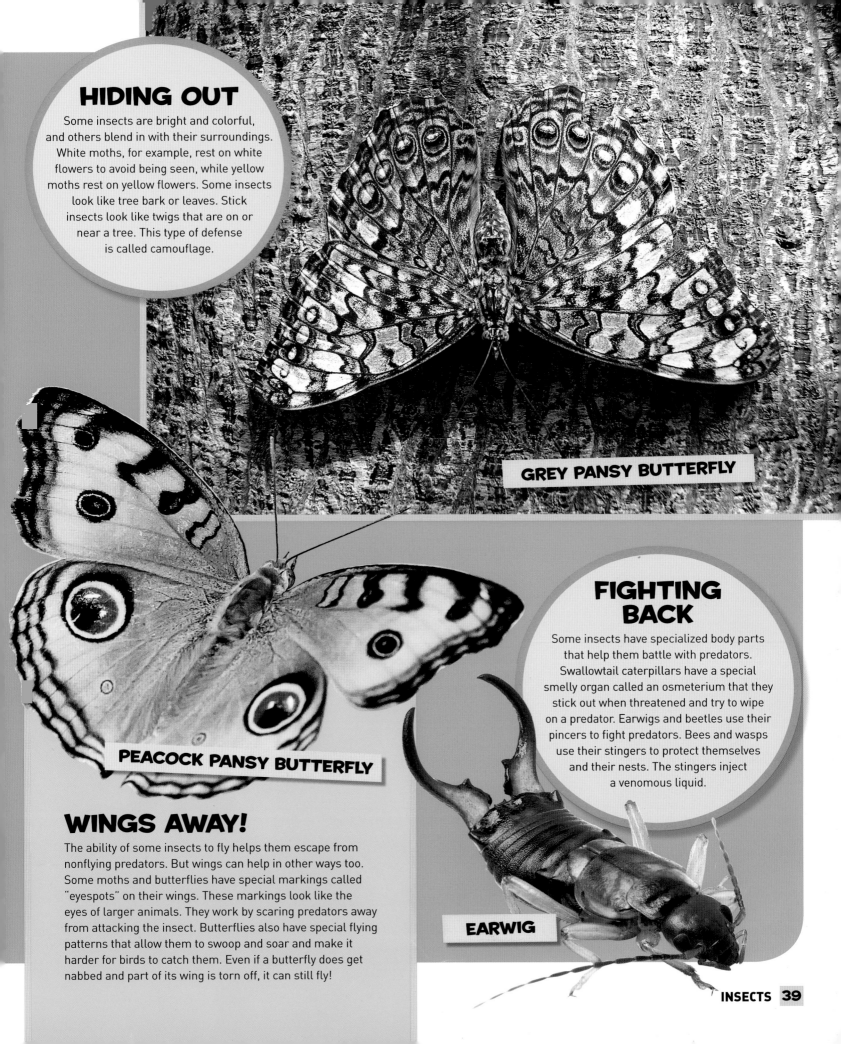

## HIDING OUT

Some insects are bright and colorful, and others blend in with their surroundings. White moths, for example, rest on white flowers to avoid being seen, while yellow moths rest on yellow flowers. Some insects look like tree bark or leaves. Stick insects look like twigs that are on or near a tree. This type of defense is called camouflage.

**GREY PANSY BUTTERFLY**

**PEACOCK PANSY BUTTERFLY**

## FIGHTING BACK

Some insects have specialized body parts that help them battle with predators. Swallowtail caterpillars have a special smelly organ called an osmeterium that they stick out when threatened and try to wipe on a predator. Earwigs and beetles use their pincers to fight predators. Bees and wasps use their stingers to protect themselves and their nests. The stingers inject a venomous liquid.

## WINGS AWAY!

The ability of some insects to fly helps them escape from nonflying predators. But wings can help in other ways too. Some moths and butterflies have special markings called "eyespots" on their wings. These markings look like the eyes of larger animals. They work by scaring predators away from attacking the insect. Butterflies also have special flying patterns that allow them to swoop and soar and make it harder for birds to catch them. Even if a butterfly does get nabbed and part of its wing is torn off, it can still fly!

**EARWIG**

# NATURE'S LITTLE HELPERS

## LIFE ON EARTH WOULD
**NOT EXIST WITHOUT INSECTS. THEY HELP**
decompose, or break down, plant and animal matter, and to pollinate plants. Insects are a major source of food for other animals, such as birds, amphibians, and bats. Even though insects are just doing their thing, eating and breeding more insects, their everyday activities can also cause problems. Insects can be pests that destroy farmers' crops and invade people's homes.

**TERMITE**

## SANITATION WORKERS
Many insects eat rotting plant and animal matter. In fact, termites—insects dreaded by homeowners—are remarkable rain forest conservationists. They clean up dead trees and plants by eating them.

**ARMY ANTS**

## PEST CONTROL
In some Amazon villages in Brazil, people welcome giant killer ant columns because they act as pest control, clearing the village of unwanted venomous snakes and scorpions. Because of their great numbers, the ants can easily overtake animals many times larger than themselves, using their powerful jaws to tear them apart and take the pieces back to their nests.

Army ant workers swarm and kill a scorpion several times their size.

**BUG BITE** INSTEAD OF USING PESTICIDES, SOME GARDENERS ATTRACT INSECTS THAT EAT PESTS.

# PLANT POLLINATORS

More than 80 percent of the world's flowering plants—including crops—depend on insects for pollination. Plants have brightly colored petals and special scents to attract insects. Bees, butterflies, flies, and beetles pollinate plants and flowers. When insects land on a plant, pollen gets stuck to their bodies. When they visit another plant, they drop off the pollen to produce new seeds.

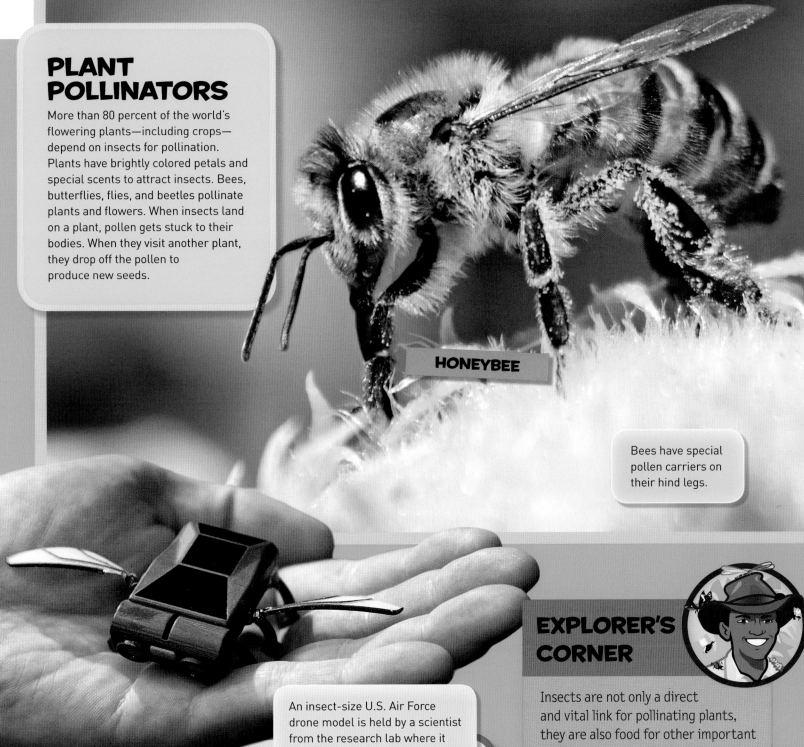

HONEYBEE

Bees have special pollen carriers on their hind legs.

An insect-size U.S. Air Force drone model is held by a scientist from the research lab where it was developed.

## INSECTS IN SCIENCE

Scientists find insects an endless source of fascination, and good models for research projects. By studying the way insects fly, scientists are able to build micro-robots that can be used for search-and-rescue missions, military surveillance, and weather monitoring. Flies are also used by forensic entomologists to determine the time of death in a murder investigation. Because flies lay eggs on rotting animal matter, including human corpses, these scientists can gauge the time of death by examining the life stages of the flies found on and around the body.

## EXPLORER'S CORNER

Insects are not only a direct and vital link for pollinating plants, they are also food for other important pollinators, such as birds, bats, and galagos, which are sometimes called bush babies (primates native to Africa). Without insects and other pollinators, we would not have some of our favorite fruits and vegetables—or even chocolate, which comes from the cacao tree. Cacao flowers are pollinated by tiny flies called midges. Without them, there would be no chocolate for us to eat!

# INSECT COMPARISONS

## YOU VS. INSECTS

**IN A 1986 SCIENCE FICTION MOVIE CALLED *THE FLY*,** a man changes into a fly. In a famous story called "The Metamorphosis," the main character slowly turns into a cockroach. The idea of giant insects freaks us out, but tiny insects are mighty in a number of ways. Here are a few ways that insect and human bodies compare.

## EYES

Most adult insects have compound eyes made up of thousands of individual lenses. This, and the shape of their eyes, allows them to see a larger area than human eyes, which have forward vision and only a single lens per eye.

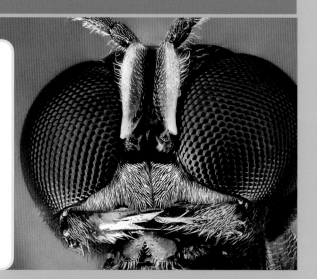

## SKELETON VS. EXOSKELETON

The human skeleton is made up of bones on the inside of our bodies. Our bones grow until we reach adulthood. Insects have exoskeletons on the outside of their bodies. Unlike the human skeleton, the exoskeleton does not grow. When an insect gets too large for its exoskeleton, it sheds it and grows a bigger one.

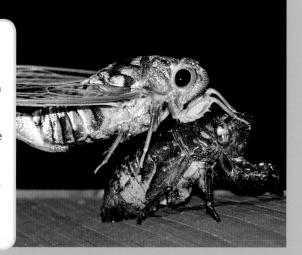

# TASTE

You taste things through the taste buds on your tongue. Some insects have a long, tongue-like part called a proboscis that they use for tasting and eating. Others taste using special organs on their feet. Bees use their antennae to taste.

# LEGS

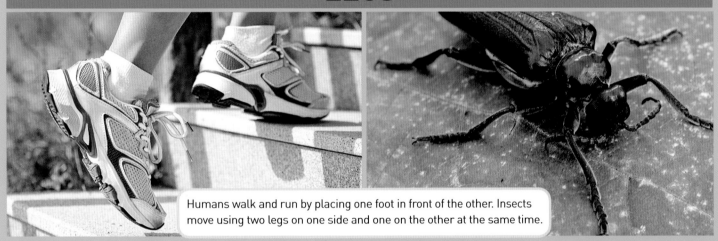

Humans walk and run by placing one foot in front of the other. Insects move using two legs on one side and one on the other at the same time.

# COMMUNICATION

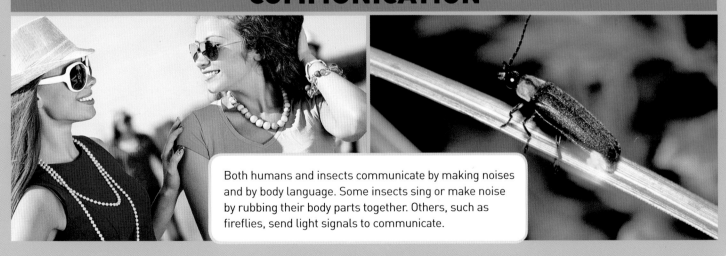

Both humans and insects communicate by making noises and by body language. Some insects sing or make noise by rubbing their body parts together. Others, such as fireflies, send light signals to communicate.

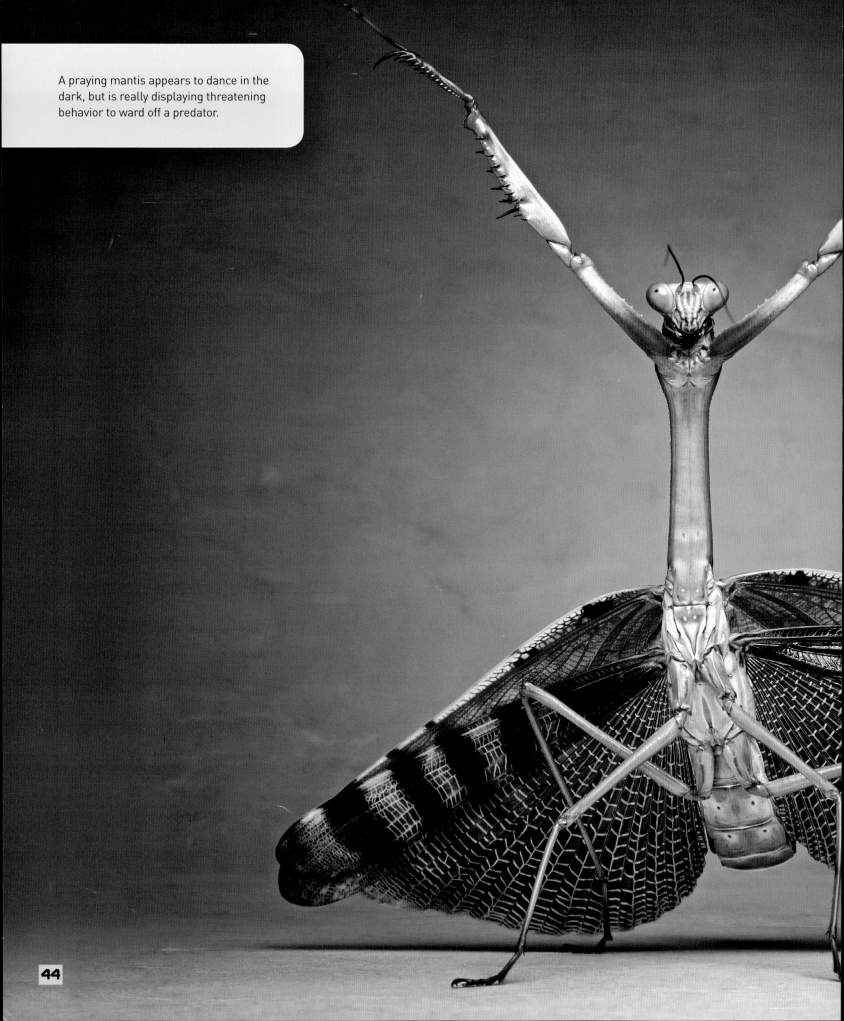

A praying mantis appears to dance in the dark, but is really displaying threatening behavior to ward off a predator.

# FUN WITH
# INSECTS

# AMAZING INSECT FEATS!

## INSECTS ARE AMONG THE
**MOST AMAZING ANIMALS. INCREDIBLY, THEY**
are the strongest creatures on the planet for their size, capable of lifting many times their body weight. But size and strength aren't everything. Take a look at these mighty insects and their other remarkable feats.

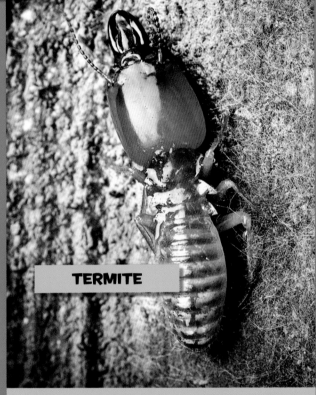

**TERMITE**

## A REAL HEAD TURNER

You can't sneak up on a praying mantis—they are the only insects capable of turning their heads 360 degrees.

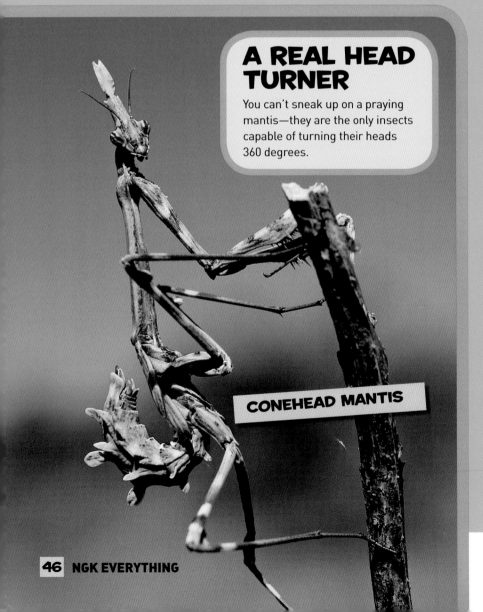

**CONEHEAD MANTIS**

## SELF-SACRIFICE

When their nests are attacked, some species of termites cause their own bodies to explode to spray invaders with a toxic chemical.

## HIGH JUMPERS

Fleas can jump 100 times their height. They have a pad of material called resilin at the tops of their back legs. When they squeeze their leg muscles, the pad releases stored energy and the fleas spring into the air. Some species of fleas can jump nonstop for hours or even days.

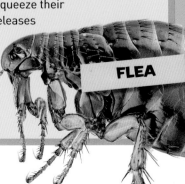

**FLEA**

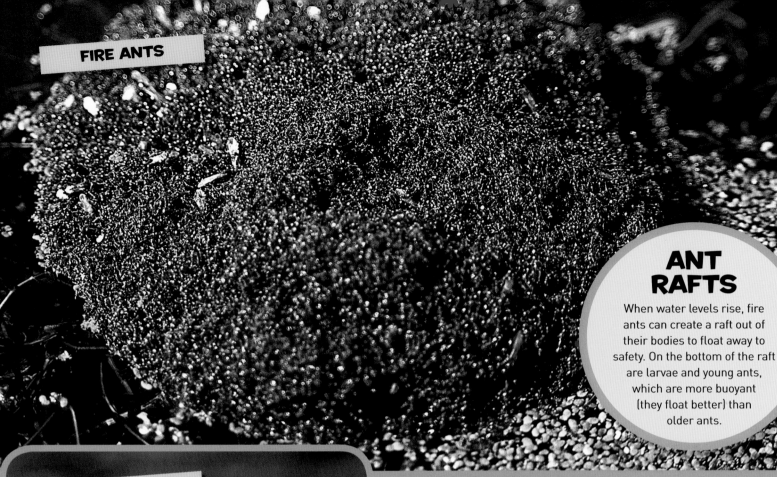

**FIRE ANTS**

## ANT RAFTS

When water levels rise, fire ants can create a raft out of their bodies to float away to safety. On the bottom of the raft are larvae and young ants, which are more buoyant (they float better) than older ants.

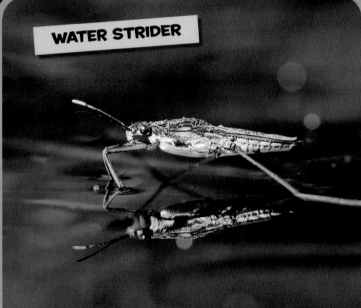

**WATER STRIDER**

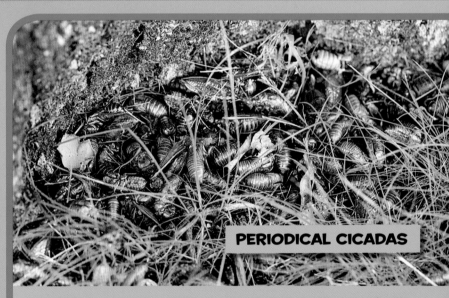

**PERIODICAL CICADAS**

## WALKING ON WATER

Water strider insects are sometimes called magic bugs because of their ability to walk on water. They use their long legs to distribute their weight across the water's surface, allowing them to slide gracefully across.

## GROWING UP UNDERGROUND

Periodical cicada nymphs live underground, taking between 13 and 17 years to form into adults. Then millions of adults suddenly emerge from the ground at the same time, but they only live above ground for less than two months before they die.

**BUG BITE** BULLDOG ANTS, WHICH LIVE IN AUSTRALIA, CAN JUMP UP TO SEVEN TIMES THE LENGTH OF THEIR BODIES.

# GETTING BUGGY

## THINK YOU KNOW INSECTS?
**TRY THIS QUIZ TO FIND OUT. ARE THE FOLLOWING** statements insect fact or fiction?

**A** INSECTS HAVE MORE MUSCLES THAN HUMANS.

**B** COCKROACHES COULD SURVIVE A NUCLEAR BOMB.

**C** YOU CAN TELL THE AGE OF A LADYBUG BY COUNTING THE SPOTS ON ITS BACK.

**D** INSECTS HAVE KILLED MORE PEOPLE THAN WARS.

**E** ALL MOSQUITOES FEED ON BLOOD.

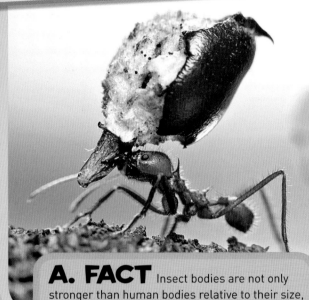

**A. FACT** Insect bodies are not only stronger than human bodies relative to their size, they also have a lot more muscles.

## EXPLORER'S CORNER

Stop before you swat! Before you go swatting away an insect, stop and think of how important it is to nature. Farmers often spray poisonous chemicals called pesticides on their crops. Pesticides help increase crop yields by controlling pests. But these pesticides can also harm beneficial insects—the pollinators.

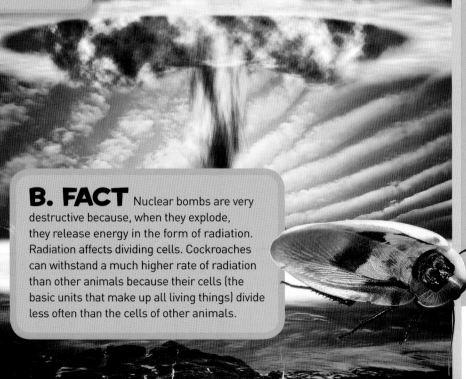

**B. FACT** Nuclear bombs are very destructive because, when they explode, they release energy in the form of radiation. Radiation affects dividing cells. Cockroaches can withstand a much higher rate of radiation than other animals because their cells (the basic units that make up all living things) divide less often than the cells of other animals.

## C. FICTION
Counting a ladybug's spots won't tell you how old it is. Most adult ladybugs can live for about one year and are born with the same number of spots they die with. But the spots can help identify the ladybug species. Some species have only two spots, and some have none at all. The spots, which are most often black on a red, orange, or orangey yellow body, are called aposematic coloration. This coloration helps protect the ladybug by sending a warning to predators to stay away because ladybugs taste terrible.

## D. FACT
Some insects transmit parasites and diseases. Fleas, for example, were responsible for carrying a plague, called the bubonic plague, that wiped out about 75 million people during the Middle Ages in an event known as the Black Death.

## E. FICTION
Many mosquitoes do not feed on human or animal blood. They eat flower nectar and juices, and decaying matter for energy. However, the females of some mosquito species do need a blood meal to make eggs and reproduce. Those are the ones who will pester and bite. Male mosquitoes don't need blood and stick to eating nectar.

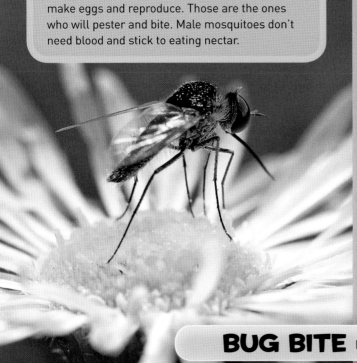

## NAME THAT BEETLE!

Beetles are never boring! For thousands of years, beetles have fascinated people through their habits, habitats, and often fantastic coloring. The study of beetles is called coleopterology. Are you a beetle fan? See if you can match the description to the beetle!

**1 JEWEL BEETLE**
Also known as the metallic wood-boring beetle, this large shiny beetle has 15,000 known species.

**2 COLORADO POTATO BEETLE**
This beetle, also called a ten-striped spearman, loves potatoes. It seriously damages crops by eating leaves.

**3 VOLKSWAGEN BEETLE**
Although it is not a real beetle, this car is shaped like one, and has been nicknamed "bug."

**4 RHINOCEROS BEETLE**
There are over 300 species of rhinoceros beetles found throughout the world. They are called rhinoceros beetles because the males have a physical characteristic that makes them look similar to a rhino.

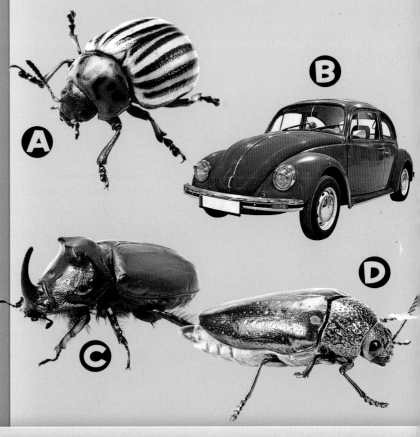

**A** **B** **C** **D**

**BUG BITE** IN JAPAN, STAG BEETLES, CALLED *KUWAGATA MUSHI*, ARE POPULAR PETS.

ANSWERS: 1. D; 2. A; 3. B; 4. C

# INSECT TWINS

## HAVE YOU EVER HEARD
**OF A DOPPELGANGER—A PERSON WHO LOOKS**
so much like you that people would swear it's you? Some insects have doubles, and some insects just act like others to avoid predators. This is called mimicry. Others just happen to look alike. See if you can tell which is which.

**A**

## 2. DRAGONFLIES AND DAMSELFLIES

Dragonflies and damselflies have long bodies and two sets of transparent wings. Though they are about the same size, damselflies are weaker fliers than dragonflies, which are among the fastest fliers in the insect world. Here's how to tell them apart. Dragonfly eyes almost always meet in the middle. A damselfly's do not. When a dragonfly is at rest, its wings are open. When a damselfly is at rest, its wings are closed.

**A**

## 1. GRASSHOPPERS AND CRICKETS

Crickets and grasshoppers have long, powerful back legs for jumping. You can tell these two insects apart by their antennae. Most crickets have long antennae, while most grasshoppers' antennae are short. Also, pay attention to the time of day you see them: Grasshoppers are more active during the day, and crickets more at night.

**B**

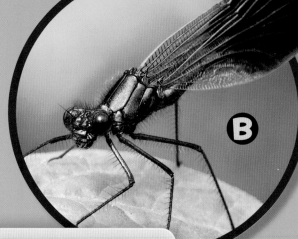

**B**

**BUG BITE** THE HUMMINGBIRD MOTH IS A DEAD RINGER FOR THE RUBY-THROATED HUMMINGBIRD.

**ANSWERS: 1.** A. cricket, B. grasshopper; **2.** A. dragonfly, B. damselfly; **3.** A. ladybird mimic beetle, B. ladybug; **4.** A. hoverfly, B. bee; **5.** A. viceroy, B. monarch

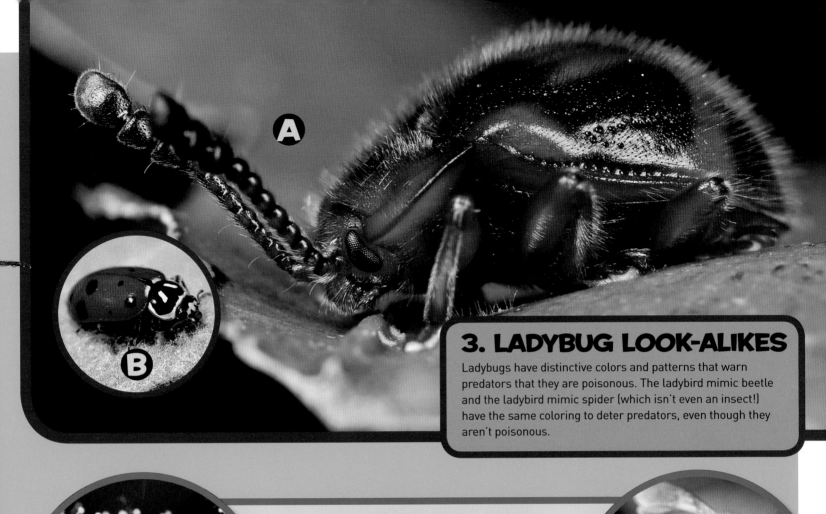

A

B

## 3. LADYBUG LOOK-ALIKES

Ladybugs have distinctive colors and patterns that warn predators that they are poisonous. The ladybird mimic beetle and the ladybird mimic spider (which isn't even an insect!) have the same coloring to deter predators, even though they aren't poisonous.

## 4. HOVERFLIES AND BEES AND WASPS

Hoverflies look like small bees and wasps. They have similar black bodies with yellow stripes. The difference between hoverflies and bees and wasps is that hover-flies cannot sting. They also have only one pair of wings, while bees and most wasps have two pairs.

A

B

## 5. MONARCH BUTTERFLIES AND VICEROY BUTTERFLIES

Monarch caterpillars eat milkweed plants, which stay in the bodies of the adult butterflies and make birds sick after eating them. Birds know to avoid monarch butterflies by the color and pattern of their wings. The smaller viceroy butterfly does not taste bad to birds but, because of its similar-looking wings, birds avoid it all the same.

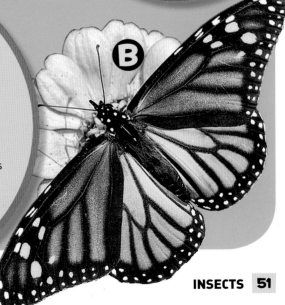

B

A

# INSECTS, INSECTS EVERYWHERE!

## HAVE YOU EVER BEEN "BUSY AS A BEE"? HOW ABOUT "SNUG AS A BUG IN A RUG"? INSECT SAYINGS, MYTHS, AND LEGENDS

have wiggled their way into many cultures over thousands of years.

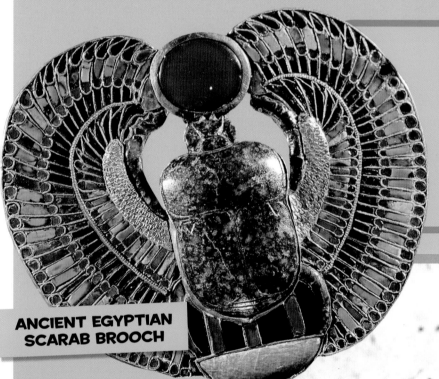

**ANCIENT EGYPTIAN SCARAB BROOCH**

## THE STUFF OF LEGENDS

In ancient Egypt, beetles were considered sacred. Amulets, seals, and jewelry were adorned with beetles. Khepri, the ancient Egyptian god of creation and rebirth, was often depicted as a man with the head of a beetle. This was because the beetles seemed to miraculously appear out of the ground. In North America, many Native Americans created legends around insects. In one Hopi legend, the people are saved from the destruction of the world by moving underground to live with the Ant People, who taught them to follow the instructions of the Creator.

## INSECT SNACK BOX

Insects are a protein-packed snack eaten in many parts of the world. They are fried, roasted, boiled, or ground up to make flour. The eggs, larvae and pupae, and adult insects are eaten. Sometimes insects are even eaten raw. Crickets are among the most popular insect snack, especially in Mexico, Thailand, and Cambodia. In Mexico, grasshopper treats called *chapulines* are sold at sporting events.

**BUG BITE** FOUR WASPS ARE NAMED AFTER *STAR WARS* CHARACTERS: POLEMISTUS, CHEWBACCA, VADERI, AND YODA!

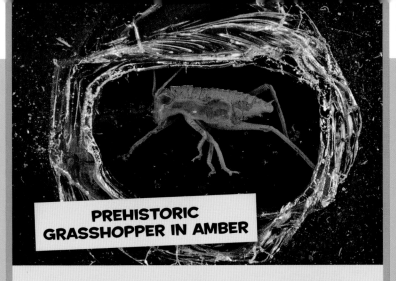

**PREHISTORIC GRASSHOPPER IN AMBER**

# CAUGHT FOR ALL TIME!

Amber is fossilized tree sap that has hardened. Some amber contains prehistoric insects that were caught in the sap millions of years ago.

# INSECT SAYINGS

Match the insect-related saying, proverb, or metaphor to its meaning.

1  ANTS IN YOUR PANTS
2  BEE IN YOUR BONNET
3  SOCIAL BUTTERFLY
4  IF YOU LIE DOWN WITH DOGS, YOU WILL GET UP WITH FLEAS.
5  THE BEE'S KNEES
6  A FLY ON THE WALL
7  A FLY IN THE OINTMENT
8  KNEE-HIGH TO A GRASSHOPPER
9  FULL AS A TICK ON A FAT DOG
10  YOU'LL CATCH MORE FLIES WITH HONEY THAN WITH VINEGAR.

A  Someone or something considered very special
B  Able to listen and watch others without being noticed
C  If you hang out with the wrong crowd, you will get into trouble.
D  An idea that won't go away
E  Can't stay still
F  Someone whose belly is full from eating
G  Someone who enjoys activities and flitting from friend to friend
H  A problem or "catch" in a plan
I  Something very small
J  It's easier to make friends when you are nice instead of nasty.

# MEALWORM CRISPIES

*Nom nom nom.* Nothing like an insect treat to fend off a growly belly. Try making these sweet snacks with mealworms, the larvae of the mealworm beetle. They can be bought from growers and in some specialty markets.

## INGREDIENTS

1/4 cup margarine
4 cups mini marshmallows
3 cups crispy rice cereal
3 cups roasted mealworms

## YOU WILL NEED

Stove
Deep pot
Spoon
9"x13" greased pan

**MARSHMALLOWS**

## DIRECTIONS

Melt margarine and marshmallows on medium heat in a pot until well combined. Watch that they do not burn. When melted, remove from heat and add crispy cereal and chopped, roasted mealworms. Stir well and spread into a pan that has been greased with some margarine. Cool and cut into pieces. Enjoy!

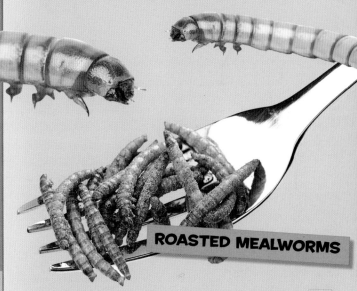

**ROASTED MEALWORMS**

# PHOTO FINISH

## BEHIND THE SHOT WITH DINO J. MARTINS

# WHEN I SPEAK TO PEOPLE ABOUT MY WORK, I OFTEN LIKE TO SAY THAT ONE IN THREE

bits of food we eat is thanks to a pollinator. Our relationship with insects is important. Their work helps us to survive as a species. I like to encourage people to make friends with insects and spend time with them. This includes watching insects and encouraging them to visit our own farms, parks, gardens, and yards. One way to do this is by planting flowers, vegetables, and other host plants that attract insects, as well as shrubs that provide wood for pollinator nests.

Another way to attract pollinators is to build bee hotels. A bee hotel is a nest you build from bits of wood, bricks, and tubes. The dry wood will attract carpenter bees (and it will keep them away from your garage or doghouse).  A bee hotel is an excellent idea for a farm or rural property, as it should be set up away from other dwellings.

In East Africa, where I do most of my work, wild bees pollinate almost two-thirds of all vegetable and fruit plants. Wild bees are among the most important group of pollinators for all flowering plants throughout the world. It is important not to view them as pests that need to be exterminated, but as insects we need to live in harmony with.

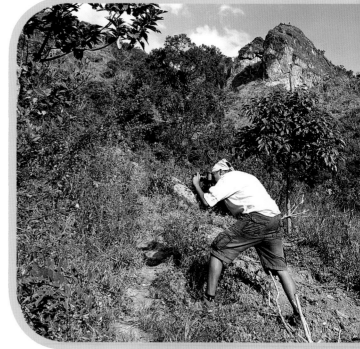

Here's Dino waiting for some giant carpenter bees to visit wildflowers at the edge of a farm in Tanzania's Uluguru Mountains. These are Africa's largest bees and are about three inches (7.5 cm) long. They pollinate many different crops in East Africa, including cowpeas, pigeon peas, passion fruits, coffee, eggplants, and several others. The male and female giant carpenter bees look very different: Females are boldly marked in black and white, while males are covered with bright golden fur!

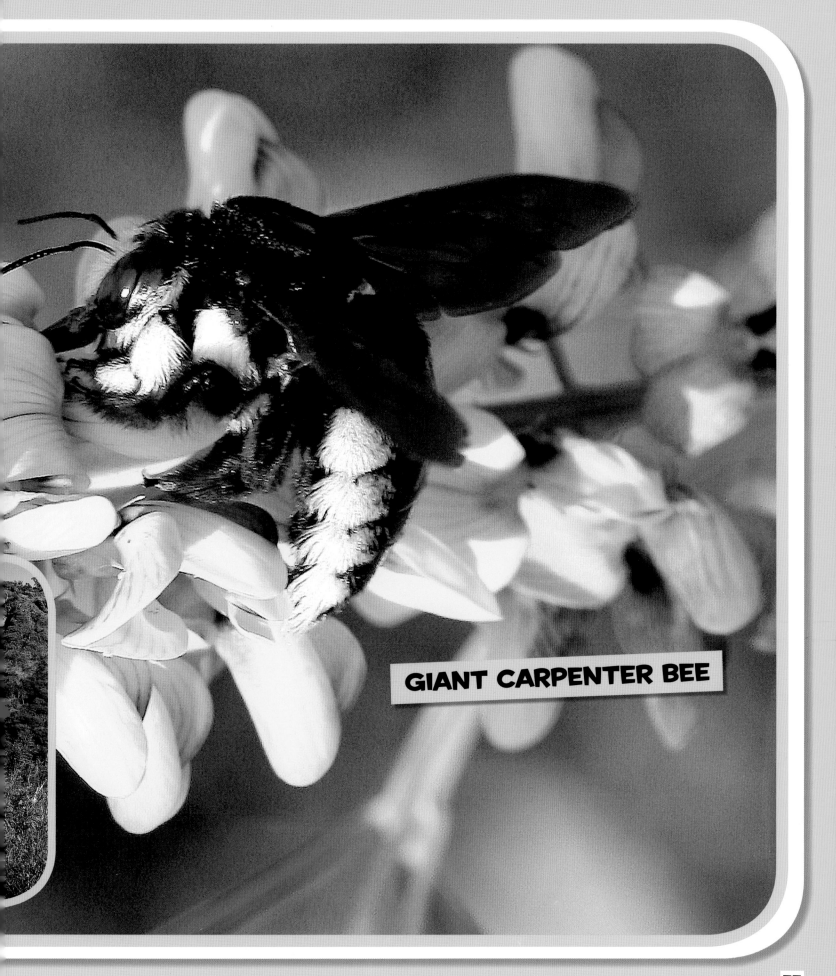

GIANT CARPENTER BEE

# AFTERWORD

## LIFE WITHOUT INSECTS

## AS HUMANS, WE MAY THINK WE ARE THE

**DOMINANT ANIMALS ON THE PLANET, BUT THE TRUTH IS, WE ARE** outnumbered. Insects rule the world in so many ways. They live everywhere, in every habitat. They can be pests and they can be providers. Insects influence the way we live, even if we are unaware of it. Without insects, life on Earth would dwindle, wither, and die. By contrast, without humans, life on Earth would continue (and some say, thrive) almost as if we never existed.

Insects are plant pollinators, helping fruits, vegetables, nuts, and seeds reproduce and spread. Insects are also soil regenerators. They do the dirty work of breaking down rotting plant and animal matter and returning the nutrients to the soil. Insects also burrow and till the soil, allowing plant roots to breathe and grow. Without insects to do all this (largely hidden) work, most animal life on the planet would starve to death.

Some insects are pests that threaten human and other vertebrate life. They compete with us for food and other resources. It costs us billions of dollars to fight them when they invade our homes or threaten us with disease. We view insects sometimes solely as villains, when in fact only a few of the billions and billions of insects on this planet pose a threat. Most insects work with us. We get far more from them than they get from us.

What would life be like without insects? Oh sure, we'd have no more creepy cockroaches, annoying flies, and freaky crawling things. But an insect-free world would be a world without butterflies flying through parks and gardens, and fireflies lighting up our summer evenings. More than that, envision a world without agricultural crops and you can imagine how important insects are.

## THE IMPORTANCE OF BEES

There's a reason why we describe a hard worker as "busy as a bee." Bees are our (almost) silent partners in the agriculture industry. They pollinate many of the plants we eat and what we feed the animals we eat. Hopefully, this fruitful relationship will continue. But honeybees are under threat. Increased use of neonicotinoid pesticides that are taken up by plants and transported to the flowers, pollen, and nectar has proved harmful to bees. Colonies are dying. Many scientists believe this could be a disaster in the making if the pesticides are not banned or restricted.

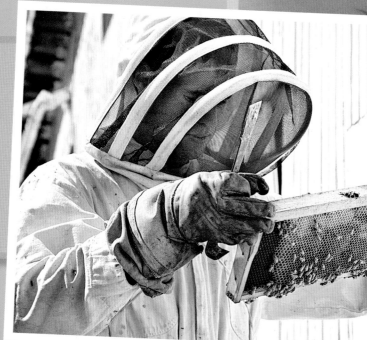

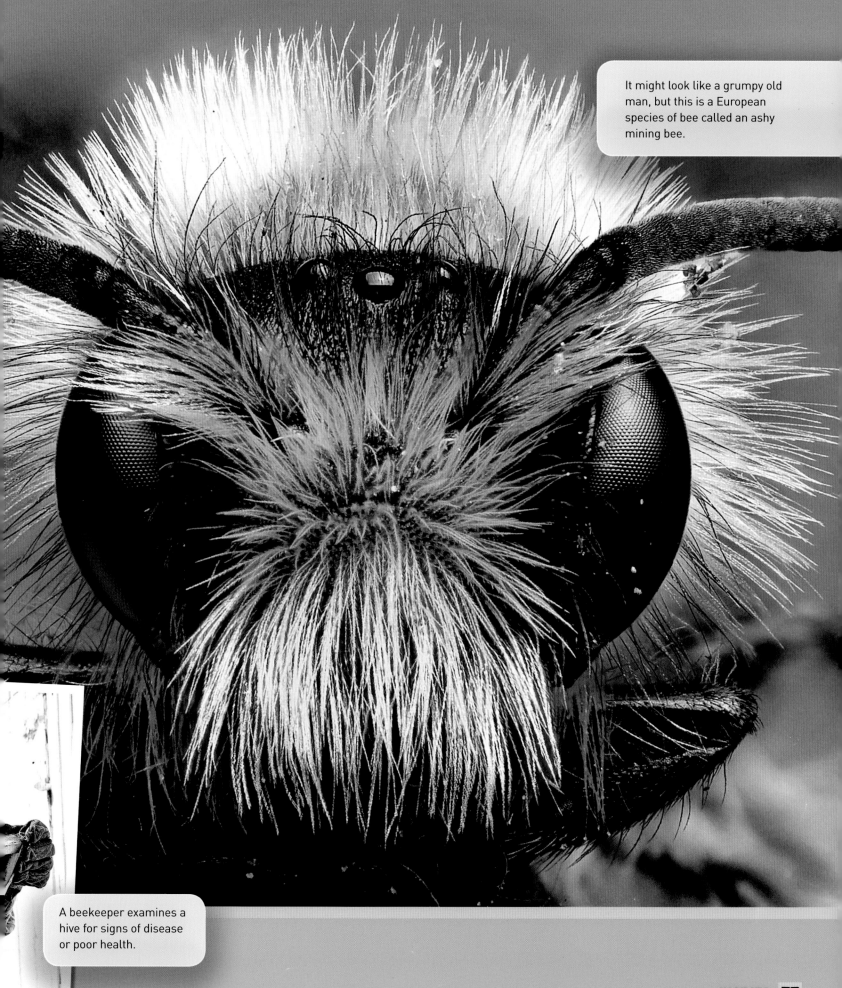

It might look like a grumpy old man, but this is a European species of bee called an ashy mining bee.

A beekeeper examines a hive for signs of disease or poor health.

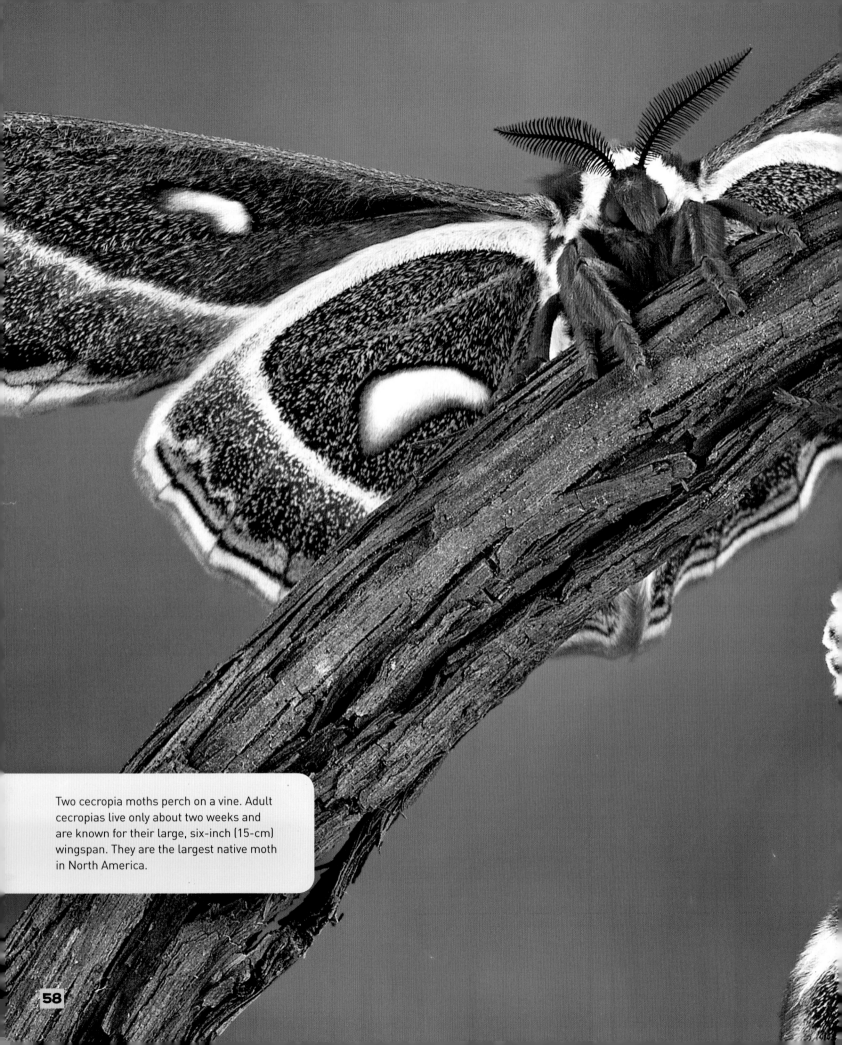

Two cecropia moths perch on a vine. Adult cecropias live only about two weeks and are known for their large, six-inch (15-cm) wingspan. They are the largest native moth in North America.

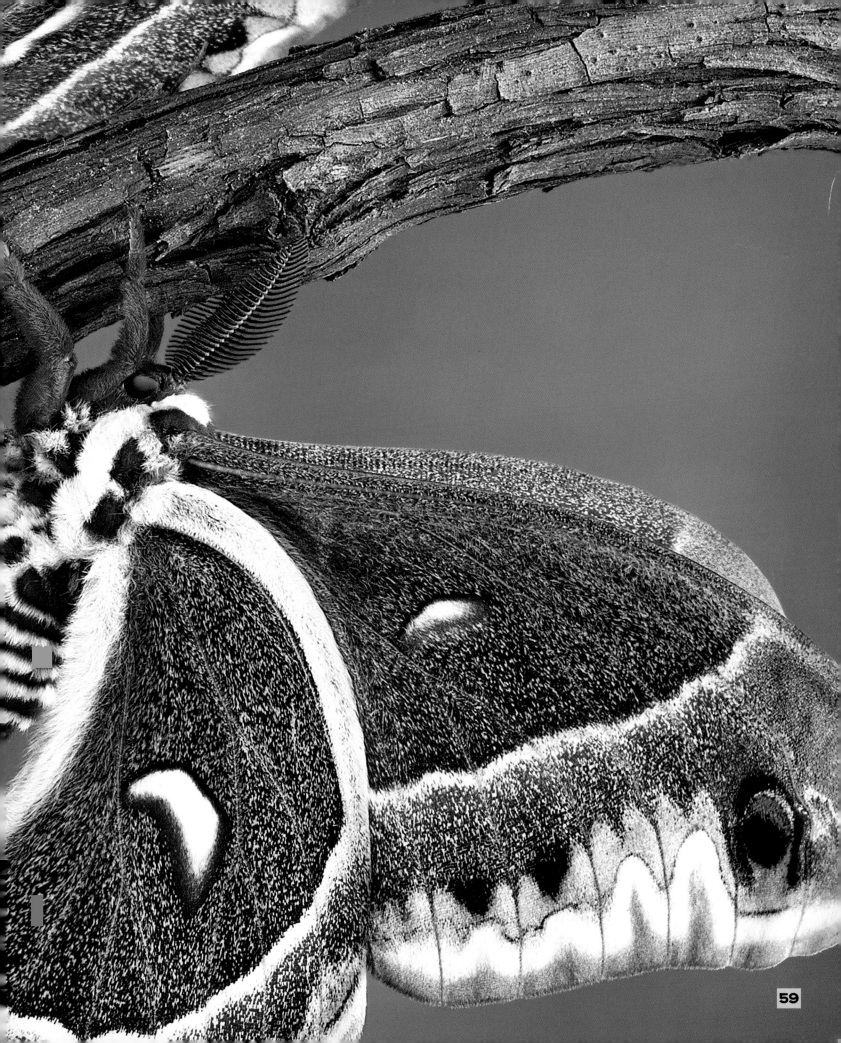

# AN INTERACTIVE GLOSSARY

## TEST YOUR INSECT INTELLIGENCE

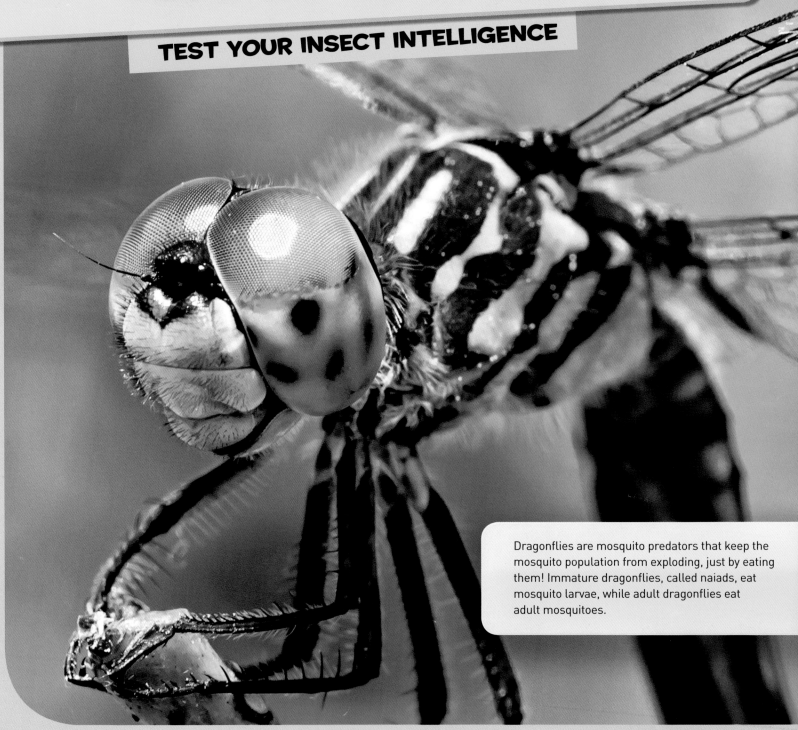

Dragonflies are mosquito predators that keep the mosquito population from exploding, just by eating them! Immature dragonflies, called naiads, eat mosquito larvae, while adult dragonflies eat adult mosquitoes.

# READ THE GLOSSARY TERMS BELOW AND THEN

## TAKE THE QUIZ TO FIND OUT HOW WELL YOU KNOW SOME OF THE INSECT BUZZ WORDS.

### 1. Abdomen
The rear main body section of an insect
[PAGES 10, 12, 18, 23, 27, 34]

**A male cicada makes noise in a part of his abdomen to**
a. attract prey
b. attract a female
c. confuse predators
d. warn other cicadas of danger

### 2. Antennae
Body parts found near the front of an insect and used for sensing objects around them
[PAGES 10, 19, 34, 35, 43, 50]

**Insect antennae are used to sense**
a. motion
b. odors
c. sounds
d. all of the above

### 3. Arthropods
A very large group of animals that have an exoskeleton
[PAGES 11, 34]

**Which one of the following animals is not an arthropod?**
a. spider
b. centipede
c. crab
d. bird

### 4. Chrysalis
The name of the butterfly pupa
[PAGES 21, 25]

**Butterfly chrysalises**
a. are long, wormlike creatures
b. eat more than their weight in food every day
c. are inside a cocoon
d. have wings

### 5. Exoskeleton
The external skeleton that supports an insect's body
[PAGES 11, 18, 23, 34, 42]

**Which of the following animals has an exoskeleton?**
a. spiders
b. humans
c. dinosaurs
d. earthworms

### 6. Larvae
The young stage of an insect's life
[PAGES 6, 8, 12, 22, 24–25, 28, 29, 47, 52, 53, 60]

**Larvae spend most of their time**
a. sleeping
b. eating
c. flying
d. mating

### 7. Mandibles
The external jaws of some insects
[PAGES 13, 19, 26, 36]

**Mandibles are specialized mouthparts often used for**
a. sucking up liquid
b. sponging up liquid
c. tasting food
d. chewing food

### 8. Metamorphosis
The process of transformation from one stage in a life cycle to another
[PAGES 22–23, 42]

**What are the two main kinds of metamorphosis?**
a. egg
b. complete
c. cocoon
d. incomplete

### 9. Nymph
The juvenile life stage in insects that undergo incomplete metamorphosis
[PAGES 23, 47]

**Nymphs**
a. shed their skin, or molt, as they get bigger
b. do not have an exoskeleton
c. never have wings
d. always live in water

### 10. Ovipositor
A body part that some female insects have for laying eggs
[PAGE 18]

**Ovipositors are found in the**
a. head
b. legs
c. abdomen
d. thorax

### 11. Pollinators
Insects that carry pollen from one flower to another to help the plant produce new seeds and fruit
[PAGES 7, 11, 15, 29, 40, 41, 48, 54, 56]

**Pollinators are**
a. considered pests by gardeners
b. known to migrate long distances
c. attracted to bright colors and strong scents
d. responsible for keeping Earth tidy

### 12. Proboscis
The long, thin tube that forms part of the mouth of some insects
[PAGES 19, 27, 43]

**Which of the following insects do not have a proboscis?**
a. flies
b. cockroaches
c. butterflies
d. mosquitoes

### 13. Pupa
The life stage of insects in which their bodies break down and reform as adults
[PAGES 22, 24–25, 52]

**If humans had a pupa life stage, it would be most like**
a. childhood
b. adulthood
c. death
d. teenagers

### 14. Thorax
The middle main body part of an insect, where the legs are found
[PAGES 10, 19]

**Insect legs can be used for**
a. jumping
b. shoveling dirt
c. tasting food
d. all of the above

**ANSWERS: 1.** b; **2.** d; **3.** d; **4.** c; **5.** a; **6.** b; **7.** d; **8.** b and d; **9.** a; **10.** c; **11.** c; **12.** b; **13.** b; **14.** d

# FIND OUT MORE

Learn more about the wide and wacky insect world with these books, movies, websites, and insect-loving places to visit.

## PLACES TO VISIT

**Butterfly Conservatory**
Niagara Falls, Canada

**Monarch Butterfly Biosphere Reserve**
Michoacán, Mexico

**National Museum of Natural History**
Washington, D.C., U.S.A.

**Natural History Museum**
London, United Kingdom

## MOVIES

*Bugs! A Rainforest Adventure*
Image Entertainment, 2007

*Eyewitness DVD: Insect*
DK Children, 2006

*The Fascinating World of Insects*
BrainFood Learning, 2011

*Life in the Undergrowth*
BBC Home Entertainment, 2006

## WEBSITES

BioKids
**biokids.umich.edu/critters/Insecta/pictures**

National Geographic Kids
**animals.nationalgeographic.com/animals/bugs**
**kids.nationalgeographic.com/kids/photos/bugs**

San Diego Zoo
**kids.sandiegozoo.org/animals/insects**

## BOOKS

*Bugged: How Insects Changed History*
Sarah Albee
Walker Children's, 2014

*Discover Insects: Fun Facts for Kids*
Rose Alden
Celandine Publishing, 2013

*Ultimate Bugopedia: The Most Complete Bug Reference Ever*
Darlyne Murawski
National Geographic Children's Books, 2013

*When Bugs Were Big, Plants Were Strange, and Tetrapods Stalked the Earth: A Cartoon Prehistory of Life Before Dinosaurs*
Hannah Bonner
National Geographic Children's Books, 2004

**BOLDFACE INDICATES ILLUSTRATIONS.**

**NG Staff for This Book**
Shelby Alinsky, *Project Editor*
James Hiscott, Jr., *Art Director*
Lori Epstein, *Senior Photo Editor*
Paige Towler, *Editorial Assistant*
Erica Holsclaw, *Special Projects Assistant*
Sanjida Rashid, *Design Production Assistant*
Michael Cassady, *Photo Assistant*
Carl Mehler, *Director of Maps*
Sven M. Dolling, *Map Research and Production*
Grace Hill, *Associate Managing Editor*
Joan Gossett, *Production Editor*
Lewis R. Bassford, *Production Manager*
Susan Borke, *Legal and Business Affairs*

**Published by the National Geographic Society**
Gary E. Knell, *President and CEO*
John M. Fahey, *Chairman of the Board*
Melina Gerosa Bellows, *Chief Education Officer*
Declan Moore, *Chief Media Officer*
Hector Sierra, *Senior Vice President and General Manager,*
    *Book Division*

**Senior Management Team, Kids Publishing and Media**
Nancy Laties Feresten, *Senior Vice President;* Jennifer Emmett,
*Vice President, Editorial Director, Kids Books;* Julie Vosburgh
Agnone, *Vice President, Editorial Operations;* Rachel Buchholz,
*Editor and Vice President,* NG Kids *magazine;* Michelle Sullivan,
*Vice President, Kids Digital;* Eva Absher-Schantz, *Design Director;*
Jay Sumner, *Photo Director;* Hannah August, *Marketing Director;*
R. Gary Colbert, *Production Director*

**Digital** Anne McCormack, *Director;* Laura Goertzel, Sara Zeglin,
*Producers;* Jed Winer, *Special Projects Assistant;* Emma Rigney,
*Creative Producer;* Brian Ford, *Video Producer;* Bianca Bowman,
*Assistant Producer;* Natalie Jones, *Senior Product Manager*

**Editorial, Design, and Production by**
    **Plan B Book Packagers**

**Captions**
Cover: Male stag beetles use their prominent mandibles to
    fight over mates and food.
Page 1: Some butterflies and moths are as beautiful as the
    flowers they feed on.
Pages 2–3: Jewel scarabs are bright, metallic insects that are
    beloved by collectors.

The National Geographic Society is one of the world's
largest nonprofit scientific and educational organizations.
Founded in 1888 to "increase and diffuse geographic
knowledge," the Society's mission is to inspire people to
care about the planet. It reaches more than 400 million
people worldwide each month through its official journal,
*National Geographic,* and other magazines; National
Geographic Channel; television documentaries; music;
radio; films; books; DVDs; maps; exhibitions; live events;
school publishing programs; interactive media; and
merchandise. National Geographic has funded more than
10,000 scientific research, conservation, and exploration
projects and supports an education program promoting
geographic literacy.

For more information, please visit
nationalgeographic.com, call 1-800-NGS LINE (647-5463),
or write to the following address:
National Geographic Society
1145 17th Street N.W.
Washington, D.C. 20036-4688 U.S.A.

Visit us online at nationalgeographic.com/books

For librarians and teachers: ngchildrensbooks.org

More for kids from National Geographic:
kids.nationalgeographic.com

For information about special discounts for bulk purchases,
please contact National Geographic Books Special Sales:
ngspecsales@ngs.org

For rights or permissions inquiries, please contact
National Geographic Books Subsidiary Rights:
ngbookrights@ngs.org

Paperback ISBN: 978-1-4263-1891-7
Reinforced library binding ISBN: 978-1-4263-1892-4

Printed in Hong Kong
14/THK/1